Al-Mansur's Book On Hunting

for Liese and Huda

Al-Mansur's book

On Hunting

المنصوري في البيزرة

An Introduction, Translation and Notes by

Terence Clark and Muawiya Derhalli

Aris & Phillips Ltd – Warminster – England

ISBN
085668 744 8

British Library Cataloguing-in-Publication Data
A catalogue record of this book is available from the British Library

Printed and published in England by Aris & Phillips Ltd, Warminster, Wiltshire
BA12 8PQ

Contents

List of Illustrationss

Photographs are by the author unless otherwise stated.

Front cover: copy by an unknown Bosnian artist of a Turkish miniature in Istanbul, showing the Sultan Bayazid out hunting, private collection.

Bibliography

AND ABBREVIATIONS

Abadi F. Abadi, *al-Qamus al-Muhit,* Cairo, 1935.
Aelian Aelian, *On the characteristics of animals,* 3 vols, ed. A.F. Schofield, London 1958–9.
Al-Baladi 'Abd al-Rahman b. Muhammad al-Baladi, *Kitab al-Kafi fi'l-Bayzara,* ed. Ihsan 'Abbas & 'Abdulhafedh Mansour, Beirut, 1983.
Anon. *Kitab al-Bayzara,* ed. Muhammad Kurd 'Ali, Damascus, 1953.
Al-Damiri Kamal al-Din Muhammad b. Musa al-Damiri, *Hayat al-hayawan al-kubra,* Cairo, 1956 & an English trans. by A S G Jayakar, London/Bombay, 1906-8.
Almagro M. Almagro & others, *Qusayr 'Amra,* Instituto Hispano-Arabe de Cultura, Madrid, 1975.
Al-Jahiz Abu 'Uthman 'Amr b. Bahr al-Jahiz, *Kitab al-hayawan,* ed. 'Abd al-Salam Muhammad Harun, Cairo, 1938.
Ahsan M. Ahsan, *Social life under the Abbasids,* London 1979.
Allen M.J.S. Allen & G.R. Smith 'Some Notes on Hunting Techniques and Practices in the Arabian Peninsula', *Arabian Studies II,* pp.108-147, London 1975.
Al-Mangali Muhammad al-Mangali, *Uns al-Mala' bi wahsh al-fala',* Paris, 1880.
Al-Qazwini 1848 Zakariya b. Muhammad b. Mahmud al-Qazwini, *Athar al-Bilad wa-Akhbar al-'Ibad,* ed. F. Wuestenfeld, Göttingen, 1848.
Al-Qazwini 1849 *'Aja'ib al-makhluqat wa ghara'ib al-mawjudat,* ed. F. Wuestenfeld, Leiden, 1849.
Al-Zabidi Muhammad b. Muhammad al-Murtada al-Zabidi, *Taj al-'arus,* Cairo, 1888.
Aristotle *HA* *History of Animals (Historia animalium),* edd. A.L. Peck & D.M. Balme, 3 vols, London 1965–91.
Arrian see Xenophon.
Austin O.L. Austin Jr & A. Singer, *Birds of the World,* London 1962.
Ben Khader Aicha Ben Abed Ben Khader & D Saren, *Carthage: A mosaic of Ancient Tunisia,* American Museum of Natural History, New York & London, 1987.
Bosworth C.E. Bosworth *The Islamic Dynasties,* Edinburgh 1967.
Brickell C. Brickell (ed.) *Gardeners' Encyclopedia of Plants & Flowers,* London 1989.
Clark 1995 Sir Terence Clark, in Goodman, see below.

Clark 2000 Sir Terence Clark, 'Coursing Hounds in Tunisia', *Saluki International*, vol. 8, issue 16, 2000.

Columella *De re rustica*, edd. H.B. Ash, E.S. Forster, & E.H. Heffner, London 1941–55.

Credland A.G. Credland, *Journal of the Society of Archer Antiquaries*. Vol. 9, 1966, vol. 18, 1975, vol. 21, 1978.

de Mayol de Lupe J. de Mayol de Lupe, *Le Levrier Persan*, Paris, 1923.

Dickson H.R.P. Dickson, *The Arab of the Desert* [4], London 1967.

E.I. *Encyclopaedia of Islam*[2], Leiden, 1995.

Finch P. Finch, (ed.) *The New Elizabethan Reference Dictionary*, London, 1959.

Fitter R. & A. Fitter & M. Blamey, *The wild flowers of Britain and Northern Europe*, London 1974.

Goodman G. Goodman (ed.), *The Saluqi, Coursing Hound of the East*, Apache Junction 1995.

Grattius *On Hunting (Cynegetica)* in *Minor Latin Poets* edd. J.W. & A. Duff London, rev. ed. 1935.

Graves P. Graves *The Life of Sir Percy Cox*, London,1941.

Groom N. Groom *Frankincense and Myrrh*, London, 1981.

Gross C. Gross, *Mammals of the Southern Gulf*, Dubai 1987.

Harrison D.L. Harrison & J.J. Bates, *The Mammals of Arabia*, Sevenoaks 1991.

Hassan Z.M. Hassan *Hunting as Practised in Arab Countries of the Middle Ages*, Cairo, 1937.

Hava J.G. Hava, *Arabic-English Dictionary*, Beirut 1951.

Heinzel H. Heinzel, R. Fitter & J. Parslow, *The Birds of Britain and Europe*, London 1972.

Hill M. Hill & P. Webb, *The wildlife of Bahrain*, Bahrain n.d.

Hollom P.A.D Hollom, R.F. Porter, S. Christensen & I Willis, *Birds of the Middle East and North Africa*, Calton, 1988.

Houlihan P.F. Houlihan & S.M. Goodman, *The birds of Ancient Egypt*, Warminster 1986.

Hourani A. Hourani, *A History of the Arab Peoples*, London 1991.

Ibn al-Baytar Ibn al-Baytar, *al-Jami' al-mufradat al-adwiya wa-l-aghdhiya*, Cairo, 1874.

Ibn Hazm Ibn Hazm, *Jamharat ansab al-'arab*, ed. 'Abd al-Salam Harun, Cairo, 1971.

Ibn Manzur Ibn Manzur, *Lisan al-'Arab*, Beirut, 1956.

Ibn Murad Ibn Murad, *Al-mustalah al-a'ajami fi kutub al-tibb wa-l-saydala al-'arabiyya*, Beirut, 1985.

Ibn Nadim Ibn Nadim, *Fihrist*, Cairo; trans. B. Dodge, New York, 1970.

Ibn Sida Ibn Sida, *Al-mukhassas fi'l-lugha*, Beirut, 1965.

Ibn Tiqtaqa Ibn Tiqtaqa, *Al-Fakhri fi adab al-sultaniyya*, Paris, 1895 & an English trans. by C.E.J.P. Whitting, London, 1947.

Khayat Y. Khayat, *Mu'jam al-mustalahat al-'ilmiyya wa'l-fanniya*, Beirut.

Kingdon J. Kingdon, *African Mammals*, London 1997.

Kopylets S. Kopylets', 'The Crymka', *Saluki International*, vol.9, issue 18, 2001.

Kushajim Abu'l-Fath Mahmud b. al-Hasan Kushajim, *Kitab al-Masayid wa'l-Matarid*, ed. Muhammad Talas, Baghdad, 1954.

Labid Labid b. Rabi', in *The Seven Golden Odes of Pagan Arabia, known also as the Moallakat*, trans. Lady Anne Blunt and done into English verse by Wilfred Scawen Blunt, London, 1943.

Lane E.W. Lane, *Arabic-English Lexicon*, London, 1867.

Löfgren O. Löfgren & C.J. Lamm, *Ambrosian fragments of an illuminating MS containing the zoology of al-Jahiz*, Uppsala, 1946.

Mansour Abdelhafedh Mansour, ed. *Al-Mansuri fi-l-Bayzarah*, Carthage 1989.

Mercier L. Mercier, *La Chasse et les Sports chez les Arabes*, Paris, 1927.

Miller A.G. Miller & M. Morris, *Plants of Dhofar*, Muscat 1988.

Mitchell A. Mitchell, *A field guide to the trees of Britain and Northern Europe*, London 1978.

Nemesianus *On Hunting*, in *Minor Latin Poets* (see Grattius).

Nicholson R.A. Nicholson, *A literary history of the Arabs*, Cambridge 1956.

Oppian *On Hunting (Cynegetica)* in *Oppian, Colluthus, Tryphiodorus*, ed. A.W. Mair, London 1928.

Philott 1908 D.C. Philott trans. of Timur Mirza's *The Baz-Nama-Yi Nasiri*: a Persian treatise on falconry, London, 1908.

Philott 1907 D.C. Philott & R.F. Azoo, 'On Hunting Dogs from *Kitab al-jamharah fi-l-'ilm al-bayzara* & Chapters on Hunting Dogs & Cheetas from *Kitab al-bayzarah* by Ibn Kushajim', *Journal & Proceedings of the Asiatic Society*, vol. III, 1907.

Pliny *Natural History*, ed. H. Rackham, W.H.S. Jones & D.E. Eicholz, 10 vols, London 1938–63.

Przezdziecki X. Przezdziecki, *Le Destin des Levriers*, Nice, 2000.

Scott Sir P. Scott & others, *The wildlife of Arabia*, London, 1981.

Smith 1981 G. R. Smith, 'Usama Ibn Munqidh's *I'tibar*', *Journal of Semitic Studies*, xxvi/2, 1981, 235-57

Smith 1995 G. R. Smith, 'The Saluqi in Islam', in Goodman, see above.

Steingass F. Steingass, *Persian English Dictionary*, 2nd impr., London, 1930.

Store G.C. Store, *A glossary of the construction, decoration and use of arms and armor*, New York, Brussels, 1961 (repr.).

Ullmann M. Ullmann, *Islamic Medicine*, Edinburgh 1997.

Varisco D.M. Varisco, *Medieval Agriculture and Islamic Science*, Seattle 1994.

Viré *E.I.* F. Viré, *Bayzara, Fahd, Hamam, Ibn 'Irs, Mahat, Na'am, Namir, Nims* and *Hayawan* in *E.I.*

Viré 1967 *Le Traité de l'Art de Volerie,* trans. from *Kitab al-Bayzara* by the Grand Falconer of the Fatimid Caliph al-'Aziz bi-Allah, Leiden 1967.

Lipscombe Vincett B.A. Lipscombe Vincett, *The wild flowers of the central area of Saudi Arabia,* Milan 1982.

Wehr H. Wehr, *A Dictionary of Modern Written Arabic,* Beirut & London, 1980.

Xenophon Xenophon & Arrian, *On Hunting,* edd. A.A. Phillips & M.M. Willcock, Warminster 1999.

Xenophon *An.* Xenophon, *Anabasis (The Persian Expedition)* tr. R. Warner , Harmondsworth 1972.

Preface

The realisation of the translation of al-Mansur's book would not have been possible without the generous encouragement of Abdelhafedh Mansour, editor of the original MS in Tunis, who kindly gave me permission to undertake the work on both al-Mansur's book and al-Kafi'sbook and supplied helpful insights into the texts. I am also deeply indebted to Adrian Phillips of Aris & Phillips on whose classical knowledge and editorial expertise I have drawn considerably. Dr G. Rex Smith gave me invaluable advice at an early stage and enabled me to avoid making some basic errors. The staff at the British Library were always most helpful in tracking down some of the obscure Arabic sources. Friends such as Jack Briggs and Mike Ratcliffe also provided useful confirmation of points of Arabic and knowledge of wildlife in Arabia respectively. Others such as Andrew Spalton and Mike Brown were generous with their photographs of wildlife. Ian Cook of Graphic Designs International did a great job on the cover illustration. I am grateful to my tutor Mustafa Ja'far for the Arabic calligraphy in Magribi Kufic script which forms the title of this book and to the teaching staff at the Institute of Arabic Calligraphy and Decoration, Baghdad, who inspired the floral designs. Above all I thank my friend and colleague Muawiya Derhalli for his never failing good humour and profound knowledge of Arabic.

There is no way of transliterating Arabic into English that satisfies both the Arabist and the generalist. To meet the requirements of the Arabist I would have had to resort to diacritic points to distinguish between certain letters and to lines over vowels to denote their length. However such markings have no meaning for the general reader and merely obscure the text. I have therefore left them out, confident that the Arabists will know the pronunciation and vowelling or can resort to the original, if necessary.

Terence Clark London, October 2001

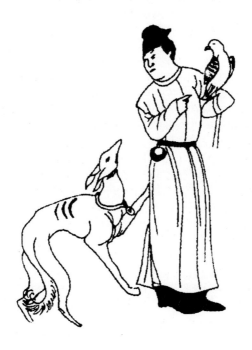

1. Falconer with a Saluqi and a hawk from a painting in the tomb of Prince Zhanghuai (d. 684 A.D.) near Xian, China.

Introduction

Hunting in its various forms has been an important part of everyday life in the Arab world from the earliest times, as for example the oryx hunt with Saluqis[1] in the pre-Islamic poem of Labid b. Rabi' so eloquently describes.[2] However in those earlier times it was not so much a pastime as a means to a source of food as well as a form of training in the skills of the *ghazu,* the lightning raid of the Bedouin. They hunted then almost exclusively with their Saluqis, as falconry appears from the poetry of the time to have been rarely practised.[3] By the time of the Umayyad Caliphs (661-750), especially the passionate hunter Yazid I who ruled in 680-683, and the greater affluence that prevailed after the transfer of the Caliphate from Medina to Damascus, hunting, including falconry, had developed into a highly organised sport. The beautiful residence of Qusayr 'Amra in the desert about 100 kms east of Amman, which was probably built by the Umayyad Caliph Walid I, who ruled in 705-715, demonstrates with its graphic murals of the chase, not to mention the *après chasse* in the elaborate baths, decorated with most un-Islamic murals of women in various stages of undress, the extent to which hunting as a sport had progressed.[4] According to some of the early Arabic treatises on hunting, the Arabs derived their knowledge of falconry in part from the Byzantines, who would have been influenced by the Romans, who we know from their mosaics in Tunisia practised the art there, and probably from the pre-Islamic Sassanians too, who may have acquired their skills from the Chinese.[5]

Organised hunting probably reached its high point under the successor Abbasid Caliphs in Iraq (749-1258), particularly under the Caliph al-Amin (809-813) who was a keen devotee. It was then regarded as a recreation, a physical exercise, a source of income and food, and above all, a well-accomplished art.[6] The *Fakhri* of Ibn Tiqtaqa , a delightful manual of Islamic politics, which was written at Mosul in Iraq in 1302, noted that the highest objective of hunting was the exercise of troops in attack and defence, in advance and in retreat; training them to horsemanship (*furusiyya*) and in shooting with the bow and arrow, fighting with the sword and the mace; it also accustomed the huntsmen to killing and to bloodshed; and provided an

1 Al-Mansur's book was written in North Africa and spells the name of these hounds as Saluqi in classic Arabic. This transliteration has therefore been used throughout, rather than any of the other Western variants, such as Saluki or Sloughi.
2 Labid , 26-30.
3 Smith 1981, 238-9.
4 Almagro.
5 Smith 1981, 239.
6 Ahsan, 202.

excellent opportunity for physical exercise which promoted digestion and kept the constitution in good health.[1]

It is hardly surprising therefore that so much of medieval Arabic literature was devoted to the noble art of hunting. Sadly much of it has been lost to us and its one-time existence is known only from references to it in other surviving works such as Ibn Nadim's monumental *Fihrist*, "an Index of the books of all nations, Arabs and foreigners alike, which are extant in the Arabic language",[2] covering the literary history of the Arabs in the 7th-11th centuries. The earliest known treatises on hunting with birds and beasts of prey (in Arabic *al-jawarih* and *al-dawari* respectively) are those written by Mahmud b. Hasan (or Husain) Kushajim (died in 961 or 971). He wrote *Kitab al-Bayzara (On Hunting)*, which served as a basic quarry of information on falconry and the art of the chase for later writers, and *Kitab al-Masayid wa'l-Matarid (On Traps and Quarries)*, which is an even fuller account of venery and falconry. Kushajim is one of two sources quoted verbatim in al-Mansur's book *On Hunting*. The other source is referred to only as al-Mutawakkili, who was probably Muhammad b. 'Abdallah b. 'Umar al-Bazyar, who wrote on raptors in *Kitab al-Jawarih* and was the austringer (literally the Keeper of the Goshawks) of the Abbasid Caliph al-Mutawakkil, who was proclaimed Caliph in 847 and was killed in 861. His work has disappeared but the essence of at least part of it has been saved for posterity in al-Mansur's book.

Sadly the first three volumes of al-Mansur's book have also been lost but this translation of all that remains of Volume IV, in the version commendably edited by Abdelhafedh Mansour, researcher at the Centre for Economic and Social Studies and Research at the University of Tunis, offers Western readers therefore a privileged window into the art of the chase as practised in the medieval Arab world. For the sighthound enthusiast it will also be a source of surprise, delight but also incredulity. On the one hand the author appears to show an intimate knowledge of the Saluqi's conformation, suggesting a hound more or less as we would know it today, and detailed experience of hunting with it; but on the other he has some extraordinary ideas by contemporary standards about the anatomy of its prey and about the properties of herbal, animal and mineral preparations for medicinal use both by humans and their hounds. To set this book in context it is necessary to look first at the historical background against which it was written.

As the opening page shows the book was presented to the Caliph and Imam al-Mustansir bi-Allah, known as al-Mansur bi-Fadl Allah (the Victorious by the grace of Allah), Commander of the Faithful Abu-'Abdallah Muhammad I b. Yahya I, who reigned over much of North Africa in 1249-77. At the back of what is believed to be the original MS, now in the library of the Zaitunah University of Tunis, is inscribed the date 645 AH = 1247 AD. This is curious as it would seem that it was written for

1 Ibn Tiqtaqa 75.
2 Ibn Nadim, Preface.

him in anticipation of his rule some two years before he actually succeeded his father. The explanation probably is that the book was written in 645/1247, while the future ruler was still Amir of Bône, and only presented and dedicated to him, no doubt in expectation of financial reward, after he became ruler in 647/1249.

The 13th century represented for North Africa a period of stability and prosperity under the Hafsid dynasty, which developed from the break-up of the western Umayyad Caliphate, previously ruled from the capital in Cordoba. Two powers emerged in North Africa to take control: the Almoravids (1056-1147) in Morocco and the Almohads (1130-1269) who ruled for a time over much of Morocco, Algeria, Tunisia and Muslim Spain. In their turn the Almohads gave way to a number of successor rulers, including the Hafsids, who had become the hereditary governors of Tunisia and took their family name from an earlier religious leader Shaikh Abu Hafs 'Umar, who died in 1176.

Al-Mansur was the son and successor of the first Hafsid ruler and in many ways its most famous. He successfully repelled the attacks of Louis IX of France and Charles of Anjou. He took from the Sharif of Mecca the titles of Caliph and Commander of the Faithful, claiming to be the heir of the Abbasid Caliph of Baghdad. Against a background of increasing affluence from trade between Africa and Europe and an influx of wealthy and cultivated refugees expelled from Muslim Spain he embarked on developing the artistic and intellectual life of his country, establishing institutes of learning and creating exquisite gardens outside Tunis and notably a hunting preserve at Bizerta. It was here in Bizerta that al-Mansur indulged in his passion for the art of the flying-hunt, which is the correct translation of *al-bayzara*, the Arabic title of this book.[1]

The word *bayzara* is derived from the Persian for the keeper of the goshawks, *bazyar* or *bazdar,* who was the master of a hawking-pack, which would consist not only of goshawks but also sakers or even eagles flying "waiting on" above and Saluqis. The Caliph al-Mu'tasim (833-842) is said to have built a horseshoe-shaped wall along the Tigris and used his men as beaters to drive the game inside, trapping them between the wall and the river.[2] It seems that al-Mansur did something similar as he hunted in a vast enclosure surrounded by a wall in which wild animals roamed. As the book shows, he also availed himself of some unusual predators, such as leopards[3], which because of their limited range would be of less use in an entirely natural environment where the prey was not confined. In this he was clearly following the example already set in the early centuries of the first millennium when the Romans ruled North Africa and were equally addicted to hunting all kinds of prey with all kinds of predators, as their mosaics of the period bear ample witness.

1 Viré *E.I, Bayzara,* 1152-5
2 Ibn Tiqtaqa 73-74.
3 Viré *E.I., Namir* and *Nimr,* 947-9, points out however that the leopard is one of the most difficult animals to train and was often confused with the cheetah.

They too had a preference for Saluqis for hunting hare and accorded them a position of distinction in their households but also used other beasts and birds of prey for the different kinds of game they hunted. [1]

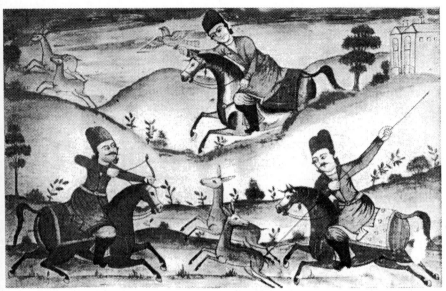

2. A Persian hunting scene

It is a matter of conjecture who wrote al-Mansur's book, since the only part that remains does not include the author's name. The editor of the original MS, Abdulhafedh Mansour, speculates that it might have been written by a learned man of religion of the time called Abu-Ja'far Ahmad b. Muhammad b. al-Hashsha', who wrote a related book explaining some of the linguistic, medical and other expressions in al-Mansur's book. All we do know for certain is that it was written in a calligraphic style favoured in the Maghrib at that time.

A close study of the text reveals that apart from the declared Arab writers a good many other much earlier classical sources were also quarried. They were probably Arabic translations of works originally in Greek and Latin, though this cannot be certain as the quotations are not attributed to their authors by name. However comparison with some of these sources shows unmistakably that many of the naive and fabulous beliefs described in the book owe their origins to the vivid imagination of the Greeks.

Within the amazingly short time of about twenty years after the death of the Prophet Muhammad in 632 the Arabs had destroyed much of the neighbouring

1 Ben Khader 61.

Byzantine and Sassanian Empires and within a century had established an empire of their own stretching from Spain in the West to the Indus valley in the East. In the process the Arabs absorbed peoples who already enjoyed a high level of Hellenistic culture but in the early years they were too involved with conquest and administering their new possessions to pay it much attention. However by the time of the Abbasid Caliphate, particularly under the Caliph al-Ma'mun (813-33), who founded Bait al-Hikma as a kind of academy for translators, works not only from Greek and Latin but also from Syriac, Persian and Indian sources became more freely accessible to Arab writers. The downside of this treasure chest was however that there was little incentive for the Arabs to undertake original research for themselves. They tended to accept what the ancients wrote without making observations for themselves based on the natural world around them.

For example, Philumenus (c. 3rd century AD) wrote a work on poisons which included a list of some thirty poisonous snakes known to the Greeks. When this list was put into Arabic the translator evidently could not equate them to snakes known to the Arabs, so he translated some of the names literally into Arabic and Arabised others with the result that they were meaningless to any Arab reader. Despite this the same names are repeated endlessly in later works even of such a distinguished writer as Ibn-Sina (Avicenna).[1] Similarly we find in al-Mansur's book an uncritical approach to the fauna which it describes. Thus, for example, in Chapter Eighteen it says that the weasel can kill the crocodile by using an almost exact copy of the method long previously described by Oppian (3.406-32) with the notable exception that Oppian's predator was the ichneumon (a mongoose), which had probably been translated into Arabic incorrectly as weasel. Equally in Part VIII it is said that if a fox mates with a female dog she will produce Saluqis. This is taken from an almost identical statement by Aristotle (607 a.1) in which he says such a breeding would produce the Laconian hound, which we know (see below) was translated into Arabic as Saluqi. Both these examples are patently absurd but illustrate the still unquestioning attitude of the Arabs centuries after the Greeks.

Greek influence is evident in two other areas in this book: medicine and astrology. Like the Greeks the Arabs believed all warm-blooded creatures were created from the four humours: blood, phlegm, yellow bile and black bile. Black bile was called *melas khymos* by the Greeks and in al-Mansur's book it appears simply in transliteration as *kimus* All these humours whether in excess or in absence gave rise to illnesses but they believed an increase in black bile from eating certain kinds of foods, such as the locusts mentioned in this book, brought on melancholy. Although astrology played only a small part in Arab medicine, it is noteworthy that in Chapter. Two the breeding seasons of Saluqis are related to the position of certain constellations. Here too simple observation of the hounds would have shown that their seasons are not related to any particular dates or constellations.

1 Ullmann 25.

However the book's main interest for sighthound enthusiasts probably lies in its comprehensive description in Chapter Three of what constitutes a good Saluqi in a form which equates roughly to the Western notion of a breed standard. It adds however an unusual pragmatic test for the selection of a puppy of the best quality, which should be left to the dam to determine in a trial by fire, from which she saves her puppies in descending order of quality. By the 13th century when this book was written the breed type had already been established long before, as recorded in al-Jahiz' encyclopaedic work of the 9th century called *al-Hayawan* (*On Animals*), on which al-Mansur's book indirectly draws extensively. It is possible to see reflections of that standard in more recent descriptions of the characteristics of the Saluqi[1] which has no doubt contributed to the maintenance of the breed type up to the present time.[2]

Like other Arab writers the author of al-Mansur's book repeats the traditional attribution of the origin of the Saluqi to Saluq, once a town in Yemen not far from Ta'izz. Professor Smith has however argued persuasively that it is more likely that the name goes back much farther to the Seleucid Empire (Seleucid in Arabic is Saluqi).[3] The author uses the name sparingly and more often than not employs the generic name of dog or, as was common among the poets and writers of his time, he leaves it to the context to indicate the subject. Some will find it disappointing that, although he clearly extols the superiority of the Saluqi over all other hunting animals, he says nothing to support the notion advanced by Przezdziecki of its unique evolution apart from the canine race.[4] In fact his attitude is no different from that of contemporary Arab Bedouin who commonly speak of Saluqis as mere dogs simply because they know no other breeds and do not feel it necessary therefore to make a distinction. This only becomes necessary in those places where common curs exist alongside the Saluqi.

The book amply confirms the present-day practice of the Arabs of breeding best to best on the basis of what they know about the hounds' lineage, appearance and performance. It also describes in fine detail the physical make-up which will indicate a hound's noble breeding and its ability to hunt strongly and intelligently. However some of the characteristics would seem strange today. For example it speaks of the feet as being small and round; whereas the modern standard speaks of moderately long feet with long well-arched toes. More striking is its insistence on the tail being short.[5] It makes it clear that this is not naturally so but a result of docking to protect the tail from damage in the chase, a notion borrowed from

1 Dickson 376.
2 Clark 1995, 405.
3 Smith 1995, 86.
4 Przezdziecki 135-136.
5 Goodman 793, the illustration, probably Persian, of a Saluqi with a half-tail suggests that the practice of docking may have continued beyond the medieval period, unless in this instance the tail was naturally short.

Columella;[1] whereas it is generally believed today that the tail is important for balance. Somewhat perversely it accepts that the tail of bitches may be left long though there is no suggestion that they were used less for hunting than dogs or that they were less successful. Similarly it states that dew claws should be removed for safety; whereas they are now regarded as an aid to turning at speed, though many remove them for cosmetic purposes.

The book's description of the eyes is also noteworthy. It describes them as being deep-set like those of other predatory animals such as lions, cheetahs and wolves, which is a rather different but perhaps more accurate way of expressing the Western epithet of "far-seeing eyes". More surprising is the inclusion of blue eyes in the standard, which is copied from Kushajim's work. Nowadays it is rare to find Saluqis with blue eyes but they may indeed have been more common until quite recent times. A French observer in the 1920s in Syria noted the native Saluqis had eyes of a range of colours including blue and bluish-green.[2] Arrian too mentions grey as a desirable colour.

However it is in his description of hunting with Saluqis that incredulity may creep in about whether he is talking about the Saluqi that we know today or some other breed or indeed the Saluqi and another unnamed breed. In this respect the book diverges markedly from Kushajim's text which deals only with the Saluqi as a sighthound. The modern Saluqi is without doubt primarily a sighthound and initially al-Mansur's book appears to be describing in Chapter One the special characteristics of the Saluqi in such a role, setting out in familiar terms how it was characteristically used on gazelle; yet in the very next paragraph he writes of it hunting by scent and indeed he devotes the whole of Chapter Five to the description of preparing and training what are clearly scenthounds for hunting hare and fox. On the other hand it is evident from the detailed list in Part VIII of the prey that was suitable for hunting that many of these animals, for example oryx, onager, gazelle etc. are more suited to pursuit by sighthounds than by scenthounds.

How can this apparent confusion be explained? Was it deliberate and, if so, was it through ignorance or was it accidental and, if so, was it through negligence? It is of course possible that the Saluqi of times past was used in a much wider role than is customary today. In Central Asia for example it seems it is indeed a much more versatile hound using scent as well as sight to locate its prey.[3] However in desert conditions there is not much scope for scenting game; whereas the open terrain is conducive to hunting by sight. Similarly in the West, where the term sighthound is applied to a whole range of hunting hounds, Saluqis are not encouraged to use their other faculties, as they are coursed over open fields and slipped only after the hare has got up and become visible. It is a well-known phenomenon that faculties

1 Columella 7.14.
2 de Mayol de Lupe 2.
3 Kopylets' 40-43.

atrophy if they are not exercised. So it is just possible that in earlier times the Saluqi hunted both by scent and by sight.

There are however many indications in the book that the author was a literary figure more acquainted with Arabic, and possibly Greek, works on hunting with hounds than with the practice of hunting itself. It is hard to imagine that anyone who had actually practised hunting with Saluqis in the deserts of North Africa could possibly describe them in the role of scenthounds, unless of course he did indeed have some other hound in mind or the hound has changed significantly in the interval. It is just possible that he meant to write about a hunting hound that combined the use of both faculties. If so he might have called his hounds *khilasi*, which al-Jahiz refers to as a cross between a Saluqi and a Kurdish sheepdog, combining the Saluqi's speed with the sheepdog's scenting ability; or, there was the *zaghari*, also mentioned by al-Jahiz, which is described as a hunting dog with a keen sense of smell probably brought to the Middle East by the Crusaders and deriving its name from the Old High German "Zeiger" [1] (pointer),[2] though some Arab sources call it *zaghuri* from the Byzantine territory called Zaghur.[3] However the only breed mentioned specifically by name in al-Mansur's book is the Saluqi. Recent research[4] has shown that the Arabs translated Aristotle's Laconian hound in his History of Animals[5] as *saluqi*. We do not know today what the Laconian hound was like and cannot be sure that the Arab translators of Aristotle knew what it was like either. It seems probable that the author of al-Mansur's book simply copied the precedents without realising that possibly one or two different kinds of hound were involved.

References to other predators in the book give only tantalising glimpses of what the missing volumes must have contained. As the author borrowed so much from earlier Arab sources it may be expected that he would have described in detail the capture and training of hawks and hunting with raptors. By way of example the appendix to this translation sets out the procedure for training the hawk to hunt gazelle in tandem with the Saluqi as described in al-Kafi's book *On Hunting*.[6] Although the author of al-Mansur's book makes a point of underlining the superiority of the Saluqi as a hunting animal, he would also have undoubtedly described what other leading Arab writers regarded as the most prized predator of all

1 Viré, 'A propos des chiens de chasse, saluqi and zagari', *REI* XLI/2, 1973.

2 Smith 1981, 235-57, sounds an appropriate note of caution about describing the function of this hound, which may have had more of a flushing or driving out role than as a pointer.

3 Ahsan, 212.

4 Correspondence between Sir T. Clark and Dr J.N. Mattock of the Department of Arabic and Islamic Studies, Glasgow University on a translation into Arabic of Aristotle's *Historia Animalium* in a possibly 17-18th century copy of a MS in Tehran based on a probably late 8th century original translation.

5 Aristotle *HA* VI,xx.

6 Al-Baladi 148-152.

- the cheetah. Here in this book in Chapters Sixteen and Seventeen we see only brief references to its training and the treatment of its illnesses but others have expounded at length on the speed and rapacity of the tamed cheetah. The Arabs favoured the sub-species of cheetah (*Acinonyx jubatus venaticus*) which was formerly found over much of Iraq, Jordan and Syria, though it is probably now extinct there. Curiously enough the northern African sub-species (*Acin. jub. hecki* or *jubatus*) appears from the literature of the period not to have been trained for hunting by the Arabs of the Maghrib and Muslim Spain. Modern mammalogists have apparently recognised the cheetah as a Greyhound with the fur of a big cat from the form of its cranium, teeth like those of canines, fixed claws, its double-suspension gallop and its tractability.[1] The similarity is obvious to anyone who has seen a Saluqi stalking its prey much as a cheetah would before the electrifying burst of speed powered by the drive from the rear quarters enabling both animals to appear to be floating across the ground in great leaps with the head held straight forward making a line with the back and with the tail as a balancing rudder.

Mention is also made of the caracal and the weasel as trained predators. The caracal was highly regarded as it was light to carry, tractable and adept at hunting both fur and feather. It was said to be capable of jumping 20' high and 40' long after wild geese, partridge, bustard, crane, etc.[2] The weasel, both in its wild form and as the domesticated ferret, was used on rare occasions to flush out game from dense coverts and for digging out fox, badger and porcupine.[3]

The list of prey in Part VIII presented particular difficulties for translation where the names are concerned. The Arabs have applied at different times in different parts of the Arab world different names to the same animal or bird. For example the oryx is called here *al-baqr al-wahshi*, literally wild cow: whereas it is more correctly called *al-maha* or colloquially *al-wudayhi* or, in dialect in parts of Oman, *bin sula'*. To compound the confusion the oryx is also referred to in some Arabic literature as *al-ayyil*;[4] whereas in this text *al-ayyil* is used to describe either wild goat or deer. The situation is even more complicated with some of the bird names. Some have gone completely out of usage and are not recorded in any of the reference works in a way which leads to their translation into English. Moreover the descriptions of some of them are minimal, so that it is impossible to ascertain from them what the author intended. Even where the description is fuller there is still scope for confusion because the same name is applied to entirely different birds. For example the normal word for francolin both in literature and in the spoken Arabic of much of the Arab world today is *al-durraj*,[5] yet in the Arabian Peninsula, where the francolin is not found, the same name is applied to the cream-coloured

1 Viré, *E.I, Fahd,* 738-743.
2 Ahsan 210.
3 Viré, *E.I., Ibn 'Irs,* 739.
4 Allen 132.
5 Viré, *E.I., Bayzara,* 1152

courser.[1] Finally some bird names appear in Kushajim in a slightly different form from those in al-Mansur's book but whether both forms existed or whether the latter were incorrectly copied is hard to say. Dr Saeed Abdulla Mohammed, who is working in Bahrain on compiling a complete list of all birds in the Middle East for Bird Life International, was most helpful with identifying some of these birds. However we had to admit defeat on some of the names.

Incomplete as it is al-Mansur's book remains a valuable contribution to the medieval Arabic hunting literature so long as it is borne clearly in mind that the author may not necessarily be talking about the same kind of hound all the time. Even if he was not a hunter himself he produced a book for hunters which conveys in all probability many of the beliefs and customs of the period not only about hunting with hounds but also with less usual predators and the animals and birds they preyed upon. As such he fits well into the tradition of other distinguished writers of the period.

3. A wolf/dog hybrid, from a late 13th / early 14th century manuscript illuminating
the zoology of al-Jahiz

1 Allen 134.

In the name of Allah, the Gracious, the Merciful

The Fourth Volume of the book presented to al-Mansur *On Hunting*

This book was written and selected for the foremost library of the Hafsid Imamate, the library of our lord and master the Caliph and Imam al-Mustansir bi-Allah, al-Mansur bi-Fadl Allah, Commander of the Faithful, Abu-'Abdallah, son of the rightly-guided Commanders, may Allah advance their affairs and perpetuate their support and victory, from various writings by Indians, Turks, Persians and learned men concerned with this matter among the people of Islam and the people of vision of all mankind.

The name of this book - al-Mansur's - was derived from the noble and imamic title of al-Mansur bi-Fadl Allah, may he be strengthened and praised.

4. A Saluqi from 'The Marvels of Creation and Their Singularities' – an encyclopaedia of cosmography and natural history, by Zakariya b. Muhammad al-Qazwini (c. 1203–1283), illuminated manuscript on paper, late Ayyubid, probably Syria, third quarter of the 13ᵗʰ century.

Part VII

Chapter One

Enumeration of the predators, their characteristics and the superiority of hounds

The *Bazyar*[1] of al-Mutawakkil[2] said and we repeat that previous authors mentioned only superficially in their books what we have presented about the situation of birds with hooked beaks other than hawks. Others, after mentioning their situation, have gone on to give descriptions of hounds as one of the carnivores. This is because hounds have common uses and characteristics which other species lack. Hounds, unlike other carnivores, are specialised for hunting with raptors.[3] They share the common characteristics of working alone and speed of the chase.

As for the extent of their range, perseverance in continuous effort and cooperation with raptors, no others are specialised in the same way. As for those which have canine teeth like them, speed of the chase, etc., they are weasels,[4] wolves,[5] mongooses[6] and the like but they do not have the same intelligence.

As for those which have canine teeth and intelligence, they are cheetahs,[7] leopards[8] and lynxes,[1] but the leopards do not have the same intelligence of the

1 *Bazyar* is a word of Persian origin meaning austringer or ostringer, keeper of goshawks. It is usually written in its Arabised form as *bayzar* from which the word *bayzara*, meaning literally hunting with goshawks or more generally the flying-hunt (Viré, *E.I.* 1152), is derived.

2 al-Mutawakkil 'ala Allah Ja'far b. al-Mu'tasim, an Abbasid Caliph, was proclaimed Caliph in 847 and was killed in 861.

3 See appendix with an extract from al-Kafi's book *On Hunting* concerning the training of raptors to hunt with hounds.

4 Weasel, probably *Mustela nivalis numidica*, which is found in the Maghrib and was used extensively in hunting (see also Chapter Eighteen).

5 Wolves are not native to Africa, except for the Simien wolf (*Canis lupus simiensis*), which probably migrated to East Africa from Western Asia, and the writer most likely had in mind *Canis lupus arabs* which is common elsewhere in the Arab world. Kushajim (see n. 14) speaks of an expert hunter who was reported to have trained wolves and lions to hunt deer, asses and similar animals (*Al-Masayid wa 'l-Matarid*, 42).

6 The text uses the Persian word *dilaq* which normally means the common weasel; but as the author is clearly trying to make a distinction here he may have intended either of its alternative meanings of the ichneumon or Egyptian mongoose (*Herpestes ichneumon*) (Lane 905) or the beech-marten (*Martes foina*) (Viré *E.I.* Ibn 'Irs 809).

7 Cheetahs (*Acinonyx jubatus*) are shown in Roman mosaics in North Africa and in Arab and Persian art. The methods of trapping a cheetah and training it, for the chase so vividly described by such writers as Kushajim and al-Mangali have been analysed and paraphrased by F. Viré in the *Encyclopaedia of Islam* under *Fahd.*

8 Leopards (*Panthera pardus*) are not known to have been trained for hunting, though they commonly appear in Roman mosaics of hunting scenes, and they were never

5. Indo-Persian miniature.

included in the orthodox Muslims' list of "beasts of prey" endorsed by the Qur'an in Sura V 4/5 as "lawful instruments" of hunting.

1 This is the caracal (*Felis caracal*), the name of which is derived from the Turkish word for lynx – *karakulak* (see Chapter Eighteen).

cheetahs. It is said that the equivalent of the cheetah in intelligence are Indian cranes,[1] but we have not seen what they do, as they have not been brought to these regions.

As for cheetahs and lynxes, these two species have special qualities which hounds share with them, especially the lynxes. These qualities are strength, cunning and opportunism at times in hunting and catching large birds.

As for those which are weaker than them, they join together in hunting them.

When they have these special qualities that distinguish them from others as well as those qualities which they share with others, they are combined in cheetah and lynx hunting either separately or together, for they may kill the gazelle individually, as cheetahs kill, and hunt hares and birds in their holes, as lynx do; and they are specialised in this hunting in a similar way to hawks and falcons. We mention their situation together with that of raptors in this second section of our book and in what follows after the custom of those who preceded us. This is because mentioning them makes unnecessary mentioning the carnivores' situation because they have peculiarities not shared by others and because they share their situation, except as we have described.

Then let us begin by mentioning something about carnivores before referring, as promised, to the situation of hounds, so that our book does not miss anything about them – with Allah's blessing.

We say therefore the following: what we take from cheetahs and leopards is their cubs and their young, but the best that is taken from the cheetahs is their young.[2] As for the lynx that we described, the best that is taken from them is their kittens in preference to their young. This is because the kittens are easier to train, while the young are bad tempered and ferocious.

As for domesticated hounds, the best are those whose pedigree is known, whose skill is good, whose physique is well-made, whose limbs are well-balanced and who have all the other conditions as we shall mention in the appropriate place – with Allah's will.[3]

After hounds, cheetahs are more commonly used than other carnivores and as their diseases and cures as well as those of the other carnivores we have described are similar to those of hounds, we have omitted mentioning them except for the odd ones peculiar to cheetahs in the place which is more appropriate to them.[4] In that way we avoid giving too much detail about the diseases of every species by Allah's will.

1 See Demoiselle Crane (*Anthropoides virgo*), p. 90.
2 Viré *E.I.,Fahd* 740, citing Arab authors, says however that it was necessary to find an animal in the prime, for the cheetah does not breed in captivity and its cubs, if deprived of their parents' training in the wild, lose their rapacity.
3 This is another formulation of the yardstick by which the Bedouin measure a good Saluqi today: lineage, appearance and performance.
4 See Chapters Fifteen & Sixteen.

Kushajim[1] said: The Arabs trace back the pedigrees of the hounds of Saluq[2] as they do with their horses.

The Prophet (peace be upon him) was asked by Zaid al-Khail[3] when he came to visit him: There are among us two men, one is called Dhuraih and the other Abu Dujanah, who have five hounds that hunt gazelle. What do you think about their prey? Allah revealed the following verse: "They ask you what is lawful for them?"[4]

Hisham quoting Ibn Abbas related that the names of their hounds were: al-Mukhtalis (Stealthy), Ghalab (Speedily Victorious), al-Qanis (Hunter), Salhab (Long-bodied), al-Sirhan (Wolf) and al-Muta'tis (Sneezer).

The females learn more quickly than the males. They live longer. Hounds live for twenty years.[5] Others are not like them. The most they produce is eight puppies; sometimes they may give birth only to one. The gestation is sixty days. The puppy is born blind for twelve days. The bitch may be mated again in the second month after giving birth but not before then. She has a blood-stained discharge for a whole week. This is indicated by the swelling of her vulva. She does not accept being mated while bleeding. She loses weight after giving birth. Her milk appears thirty days after becoming pregnant.[6] The first born is well-muscled.[7] The female urinates squatting down. Some cock their legs: in Arabic they say for this: qazaha bi-bauli-hi and shaghara.

The female's first-born is smaller, as is the mare's and the woman's. The first egg is smaller too. Males become sexually mature before females in the year. The female is sarif [8]or mustahrima if she refuses to mate and the mating of hounds is called mu'azala.[9]

1 He is Mahmud b. al-Hasan b. al-Sindi ibn Shahik, Abu al-Fath, died 970, author of al-Masayid wa-l-Matarid (On Snares and Quarries).
2 Saluq is a village in Yemen from which, according to Arab tradition, the hounds are said to derive their name. But it is more likely that they derive it from the earlier Seleucid (Saluqi in Arabic) empire, Smith 1995, 86.
3 Zaid al-Khail b. Muhalhil b. Zaid al-Ta'i met the Prophet in 631, accepted Islam and was called by the Prophet Zaid al-Khair (the Good). It is said that he died in a praiseworthy manner as he was returning to Madina towards the end of the Caliphate of 'Umar bin al-Khattab.
4 Qur'an, V/4 "The Table", the rest of which is: "Say: good things are lawful to you, also what predators you have trained as hounds; you train them in part what Allah has trained you, so eat what they catch for you, mentioning Allah's name over it".
5 This would be an exceptional age, particularly in the Arab world where it is uncommon for hunters to keep Saluqis much beyond their hunting prime, say, 4–5 years old.
6 Most of this paragraph repeats Aristotle's comments on the Laconian hound, though he says the bitch may not be mated again for 6 months (HA 574a16–575a10).
7 Allen n. 42.
8 Kushajim 132, adds the words "idha hajat", meaning "if she is on heat".
9 Kushajim 132, gives the correct spelling as shown; whereas al-Mansur's book gives "mu'adala".

Hounds shed their front teeth and replace them. This is not apparent to many people because the hounds do not spit out a tooth until another has grown in its place. Other beasts of prey do likewise, except for the incisors. Every hunting animal that has incisors sheds them in an obvious fashion. The way for the stranger is to be friendly until sure of the fact. So long as the animal's tail is drawn up between its legs to its belly it is unhappy.[1] If it lifts its tail, it is pleased.

One of the things to make it friendly is for its master to feed it a piece of bread and honey and to chew some food and spit it into its mouth. It then becomes friendly. It is said in Arabic that the hound *basa'a* with its master if it becomes friendly with him; and the bites of hounds are gentle with him – *basa'at*.

The hound's characteristics

It is said that its entire head is of one piece of bone. If it sees some gazelle, whether near or far, it can pick out the weak from the others or the does from the buck. When it sees a herd it makes a beeline for the buck, even though it realises that it is stronger and can jump farther. It ignores the does, although it knows that they are weaker at running, because it knows that if the buck runs two courses it retains its urine. It can happen to every animal either that it is incontinent and has colic or that it retains and stores up its urine. When the buck retains its urine it is because of the effort of running and the difficulty of bringing its legs together and lifting them up. Thus it is forced to shorten its stride.

It is overcome by breathlessness and the hound catches up with it. Whereas does that feel the need to urinate do not hold it back but urinate because of the width of the passage. The hound knows this naturally and does not need any experience or teaching.

If you take the hound out hunting on a day of ice and snow on the ground when neither foot nor paw is sure and it goes on without knowing the location of the hare's burrow in the ground[2] or the gazelle's covert or the fox's hole or where other entrances are, it moves forwards and backwards, from right to left, sniffing and smelling until it marks the entrances to those holes and tries to ascertain what is inside them. For the breath of the animals hidden there and the vapours from the inside melt down the snow until it softens at the mouth of the burrow, which is concealed and obscure and no hunter, tracker or farmer can find it.

It is also used for mesmerising the francolin,[3] for climbing up behind the hare on the high ground of the plain and reaching where there is no hiding place.

1 The tail in this position is usually indicative of a Saluqi being afraid or unhappy.
2 Philott 1907, 599: in the East it is noteworthy that hares go to ground.
3 Allen 134: the Arabic is *al-durraj*, which is the name given to the cream-coloured courser (*Cursorius cursor*) in the Arabian Peninsula. However in other parts of the region this is the name given to the francolin (*Francolinus francolinus*). The text does not indicate which is meant here but the longer description of it in Part VIII suggests that the francolin is more likely. See also Viré, *E.I., Bayzara* 1152.

Among its characteristics

It recognises the dead or those pretending to be dead. It is said that the Magi[1] do not bury their dead until a dog has been near them. It seems that it gives a sign by smelling it whether it is alive or dead.[2]

Likewise the fox's trick does not deceive it, if it pretends to be dead. Indeed the fox does not even try it on with it; it tries it on with the crow and others which can be fooled by pretending to be dead. It inflates its stomach until it gets near to it and, if it desires it, it catches it.

The dam passes on to her puppies the characteristics of the sire in full.

It is mentioned that making it walk ahead on frozen rivers is not because of the firmness of its tread but rather because of its sensory perception. If it hears water running it will not cross.

It has very keen sight. All predators look out for themselves except hounds which work for their masters.

One of the things known about it is when it overtaken by old age. If its teeth are black and broken they indicate old age and if they are white and sharp they indicate youth.[3] The male's teeth are larger. It is strong at chewing, eating[4] and digesting its food. If a piece of meat is thrown to it, it picks it up and tries to eat it where it is not seen. It keeps looking around it and bites on the bone to break it into pieces. If it is prevented and it is something it enjoys, it gulps it down confident that it will find it digestible.

There are no animals on earth with a prominent penis than man and hound. No other copulating animals are more adapted to each other in their nature than they.

1 The Magi or wise men were an early cult in Media (part of modern Iran) who were taken over by the Zoroastrians. The Magi believed that dead human bodies must not be allowed to defile the sacred elements of earth, fire and water and were laid out on the top of so-called Towers of Silence for the vultures and pariah dogs to pick clean of flesh before the bones were interred. The Zoroastrians and the Parsees followed this practice.

2 Al-Jahiz recounts this story in *al-Hayawan* (1/375).

3 Cf. Aristotle *HA* 575a6–12.

4 Kushajim 135, gives "*khadam*", meaning "eating food"; whereas al-Mansur's book gives "*hatam*" , meaning "smashing dry things", which seems inappropriate.

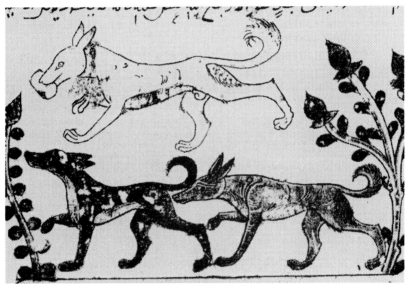

*6. Three dogs from a late 13th / early 14th century manuscript, illuminating the
zoology of al-Jahiz*

Chapter Two

Hounds' breeding seasons

7. Capricorn from a 13ᵗʰ / 14ᵗʰ century illustration of the constellation by al-Qazwini

From al-Mutawakkili:

Hounds have two times for mating: one is early and the other is late.[1] The early one is on the first of January when the largest bright star[2] is parallel to the middle of Capricorn.

The late one is on the first day of February when the largest bright star is parallel to the middle of Aquarius.[3]

If one of these two times occurs, let it rest for some days from running and hunting. Let it rest until the time of its season. Then allow the mating 10 days after it has passed blood, when the reproductive organs are ready.[4]

The best of the males and females are used for breeding when they are two years old.[5] Hounds younger than this are not used. If the time for mating them comes, confine them in some empty place where they see no one.[6] That is better for obtaining puppies of excellent quality. If the females are mated they are walked slowly. They are prevented from running and going out hunting for thirty days and if the females are pregnant, let them rest from going out hunting.[7]

1 Arrian 29 also notes two seasons for breeding hounds but says more reasonably that the better season is the spring; whereas the autumn is less good. In fact there are no set times for hounds' seasons.

2 Kunitsch, *E.I.,* 100, *Nudjum*: there was with the Arabs an ancient tradition of the "Thirty Bright Stars", of which this was presumably the largest.

3 Varisco 25, 30 & 38, suggests that the bright star is usually followed by its name but in these two instances the stars are not otherwise identified.

4 Arrian 27.1 makes similar observations. It is generally reckoned today that the optimum time for mating a Saluki bitch is 10-12 days into her season but many bitches are irregular in this respect.

5 This confirms present Bedouin practice of breeding best to best but Arrian 26.4 suggests three years is the best age for breeding.

6 Arrian 28.1 and Grattius 279-287 make the same point.

7 However Arrian 28.2 recommends taking them out to the hunt but only walking them as this keeps their strength up. Grattius *idem* is more cautious and recommends rest.

Be easy also with the male after mounting and do not let it go out hunting or run, because if they run, they will drop.

The period of gestation is sixty days,[1] though this number could increase according to the number of male puppies in their wombs, because one day must be added for every male puppy in their wombs. When the time comes for the birth and it is difficult for them, necessity dictates that you must abort what is in their wombs. Take some seeds of the violet,[2] as required, boil them in water and give them the water to drink. They will then abort what they have in their wombs.

If not, take some ashes, as required, knead them into a paste with a mixed sherbet and put it into the reproductive organs.

Or, take some black hellebore,[3] as required, pound it, mix it with salt and feed it to them and it will abort what is in their wombs.

When the hounds have given birth the reproductive organs should be cleansed. Take some lentil flour, mix it into a paste and bake a round loaf of it. Let it dry, take as much as you need of it, render it with some leeks and let them cook. Strain the liquid and give it via the nose. That way they are cleansed.

If you want to accelerate conception, then deprive them of food for a day and feed some leavened bread in the evening. Or, take three grains of salt and give them to them, then let the males mount them afterwards. This will accelerate conception. If the studs are incapable of mating and are too weak and if you want to restore them, take some medicine which is called *qabi'dubus*,[4] some pepper and rue[5] in equal proportions and a little saffron, which you mix, pound and sprinkle with old sherbet and hot water. Pour it down their throats and it will do them good.

Or, take some raw lupin[6] and cook it with some mutton, chicken or pork, then feed them with the gravy and it will do them good.

If they are injured on mounting and cannot mate, pour some hot water on the injury or take some cream and rue, boil them together and daub it on the place of the injury.

Or, take some wax and oil, as required, mix them over a fire until they become of the consistency of ointment. Daub the place of the injury with it and it will do it good, if Allah wills.

1 Arrian 28.3 also says sixty days, although the average gestation is 63 days. Al-Jahiz: *al-Hayawan* 2/220: the female Saluqi is pregnant for a sixth of the year, ie 60 days, though this might increase by a day or two.

2 *Viola adorata*, Lane 259.

3 It is not clear whether this refers to stinking hellebore (*Helleborus foetidus*) or green hellebore (*Helleborus viridis*).

4 A note in the margin of the original MS says that this is unknown.

5 It is not clear whether this is the wild goat's rue (*Galega officinalis*) or the cultivated common rue (*Ruta graveolens*).

6 This could be either the wild lupin (*Lupinus nookatensis*) or the garden lupin (*L. polyphyllus*).

Chapter Three

Observations on their good qualities and their faults

From al-Mutawakkili:

If we succeeded in explaining what we wanted about knowing the times when hounds breed, the length of their gestation and how to deal with them in this regard, we relate in this chapter some detailed observations indicating their good qualities and their faults. That will be one of the things that will help you to know in advance about the good qualities before starting work with them, if Allah wills.

One of the ways which will help to know in advance about the excellence of their puppies and their intelligence is to use a test at delivery in a circle of dry grass. The puppies are put inside and their dams are held so that they can see them. The ends of the circles are set alight and when they have caught fire their dams are freed. They take them from the fire one at a time and the best of them is the one that is brought out first and the following one is the second best. As each one's transfer comes next, it will be better than the succeeding one to be rescued and the worst will be the last to be rescued.

What also indicates the good quality of their puppies is their weight. The one which is heavier than the others is better than the one which weighs least.

From Kushajim's book:

If the bitch gives birth to one, it will be the best.[1] If it gives birth to three of which one is a bitch resembling the dam, it will be the best of the three; and if one of the three is a dog, it is better than the other two. When the puppies are small and cannot stand on their legs, take them to a hilly place and whichever walks on all fours and does not fall much is the best.

From al-Mutawakkili:

It is most necessary to remove the rejects from these tests from their dams and to leave the best of them to be suckled. The rejects are given to another bitch to foster them. If it does not suckle them, take some milk from a bitch which has refused to suckle and mix it with saliva and spread it on the backs of the rejected puppies. Then if it licks them and smells them it will foster them and suckle them. When the dams' milk is too little and they need more, take some bull's lungs and burn them. Feed the puppies the ashes with their food and it will save them.

As for discerning the excellence of what has been selected, it has nothing to do with what sort of colours they are, which are cream, red, black, white, greyish, fawn,

[1] Philott 1907, 47: translates "*afrah*" as "best" rather than the usual meaning of "clever" or "lively". Kushajim's text inserts here another sentence: "If it gives birth to two, the male is better than the female.".

blue, black and white, ash[1] and the like, because they tell you nothing about their qualities, but the purpose of selecting certain colours is merely to find them pleasing to look at. It may be that the colours of some are ugly, hateful, which are superior to those of a better colour. When you examine them their keenness, the beauty of their shape, their bone structure and their moderate build show that they are good.

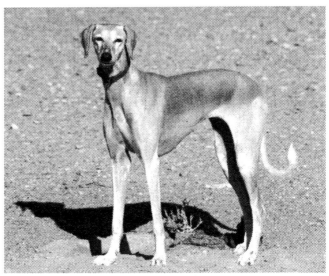

8. Tribal Saluqi, Iraq.

From Kushajim's book:

The black ones tolerate less well heat and cold; and the white ones are better if they have black eyes.

Some people claim that the black ones tolerate the cold and believe that they are stronger. Certainly every black animal is stronger than any other colour.[2]

From al-Mutawakkili:

As for the good qualities indicating the noble breeding of those chosen for mounting, the best are those which have refined heads with wide, raised tear ducts; loose, fine, long, wide-spaced, floppy ears, as if moulded to their necks, with long,

[1] These are all colours to be found among eastern Saluqis. The Arabs say green for a hound which is called blue in the West. Solid black is very rare: there are usually some white hairs present either on the chest or the feet.

[2] In practice colour does not seem to play a role in the ability of Saluqis to hunt in any conditions. Though light-coloured hounds are more common in desert conditions, black hounds are also found there and do equally well.

soft hair; foreheads with many veins; prominent orbits of the eyes which are contiguous with their foreheads and the corners of their mouths in line with their eyes; a long, fine snout; sharp, wide, sparkling eyes with strong, black pupils, deep-set like the set of the eyes of lions, cheetahs and wolves;[1] sharply pointed noses; wide mouths; bright, shining, beautiful faces, with full napes on long necks; wide, fleshy shoulders; long between their stomachs and their chests; moderate, well-muscled spines, connecting the powerful flanks with their stomachs and their backs; prominent, oval, well-muscled hips, protruding more than their forequarters; fleshy and with fine hair in the soft parts of their stomachs; small, round, hard, symmetrical feet; long between the forelegs and the rear legs; short-backed, moderate limbs; fine, short tails, well-formed, firm, taut, with the ends docked;[2] powerful, firm muscles; the hind quarters higher than the forequarters and the rear legs longer than the forelegs; hard nails; long, well-made bodies with long, soft hair. If these or most of these characteristic features are present, it indicates their long descent and noble breeding, their perfect skilfulness, and their strong running, if Allah wills.[3]

As for the good qualities indicating the noble breeding of the males selected for hunting, they should have small heads, hollow gullets and lean cheeks, with a noble stop,[4] and lots of saliva; that indicates they have plenty of stamina.

They should have wide nostrils, prominent foreheads and chests, pendant ears, prominent ribs and the two pieces of cartilage of the widest rib, wide, deep chests, and short backs: this is an indication of their running power. [Those with fine, short tails are the best bred.][5]

Those with lean flanks and back, but not dry with poor backs and croup, are the strongest at running.

Those that are sharp-witted and energetic, and dislike leads and chains are of noble breeding.

Those that are many-coloured and shaped like bitches, with many prominent veins on the face, broad backs, lean flanks and tightly looped tails show their running power, their pure breeding and their skilfulness.

Those that have tails well clear of their hocks show their nobleness of character and the strength of their backs.

[1] Arrian 4.5 refers to eyes like those of leopards, lions or lynxes.

[2] Columella 7.14 says: "It will be found best to cut the tails of puppies forty days after birth in the following manner: there is a nerve, which passes along through the joints of the spine down to the extremity of the tail; this is taken between the teeth and drawn out a little way and then broken. As a result the tail never grows to an ugly length and (so many shepherds declare) rabies, a disease that is fatal to this animal, is prevented".

[3] This description amounts to a breed standard and reflects similar descriptions in Xenophon 3-4 and Arrian 4, 5 and 6, although the Arabs drew a distinction between the standard for dogs and that for bitches which is not found in the Greek texts.

[4] Literally what is between the eyes and the snout.

[5] In parentheses is a marginal note on the MS.

As for what is regarded as faults, it is everything opposite to these descriptions, especially if they are humpbacked from the croup. This makes them failures and lacking in breeding.[1]

As for the good qualities indicating the noble breeding of the bitches selected for hunting, those that have black or blue prominent pupils; large eyes; soft mouths, with coarse tufts of hair below the jaws and on their cheeks too; broad, deep and long chests, as if they are dragging on the ground; prominent withers; fine waists; long, full thighs; strong muscles with the skin stretched tight between them; the two bones, adjacent to the thighs and the pelvis should be small, measuring three fingers;[2] and a balanced back: this shows their keenness.

Those that have their hind quarters higher than their front are faster at running uphill, downhill and on the flat.[3]

Those that have their fore quarters higher than their rear are not fast at running, except on the flat.

Those that are black are more tolerant of cold than of heat.

Those that are white are keen if they have black eyes.

Those that have dew claws on their legs or loops on the base of their tails indicate their pure breeding, so dock them in order that they do not wound them when running.[4]

These are the conditions indicating their keenness and pure breeding and those that are contrary to this description of their traits of character are contrary to keenness.

Those that are broad between the joints of the root of their well-muscled tails are more pure bred and make less mistakes in hunting, contrary to what has been said before that males should have short, fine tails.

Those that keep their toes together when walking or running are better than others because that prevents mud and dirt entering between the interstices.

From Kushajim's book:[5]

The indications of a good hound are: long between forelegs and hindlegs, short in the back, small in the head, long and broad in the neck, floppy-eared with breadth

[1] Arrian 6.3.

[2] This probably refers to the distance between the points of the ilia which according to the Bedouin in Iraq and Syria today should measure three fingers, cf. Allen 124, though Dickson 376 records the width of the whole hand including the thumb.

[3] Copied straight from Arrian (5.10).

[4] It is noteworthy that ear cropping is not mentioned, although it is a common practice today, particularly in the Kurdish areas of northern Syria, Iraq and Iran and in parts of N. Africa, where it is done not only to prevent injury when running or fighting but also for beauty, speed or identification (cf. Clark 1995, 157)

[5] Kushajim 136.

between the ears as if they cling to the neck, large, wide-spaced, blue eyes[1] with prominent pupils, a long, fine nose, ample jowls, a wide prominent forehead and strong opposition to the leash.[2]

The indications of pure breeding are that it should have under its chin a single tuft of coarse hair and the same hair on its cheeks.

It is desirable that it should have small forefeet and long hind feet as this is good for hills and for dealing with hares, which cannot be caught in the mountains unless the feet are like this; a long, broad, deep towards the ground brisket, the upper half prominent; broad upper forelegs; straight forefeet with the toes close together so that dirt and mud can hardly enter between them; broad between the shoulder joints; broad between the groins of the long, well muscled thighs;[3] a well-balanced back; a good cut up; a long flap of skin between the top of the thighs and the brisket; straight back legs with no bend for the knees; short pasterns; a short, fine tail, hard as a stick, but it is not a fault if the tail of the bitch is long; and soft hair over the whole animal is desirable.

Al-Ma'mun[4] said to a man: "Buy me horses!" The man said: "I have no eye for horses, I am rather a hunter." " Do you not have an eye for hounds?" The man said: "Yes." "Then look for everything which you would aim for in the keen, well-bred hound and seek the same in horses."

The sign of good breeding is: a curved end of the tail to the pastern and it is right that it should be docked. If the hound takes its kill alone, perhaps it will go farther and take gazelle or onager or mountain goat,[5] which is possible only by those of strong constitution in a pack of two or three and if they are not outrun by it and are not afraid of its horns.

As for hare and fox, the hound will take them single-handed, provided it does not catch the hare in the mountains or the fox does not dodge about. If it does not go to ground, it will catch it. It may be that it turns towards the hound whose tongue is hanging out from running and it bites it and drives it away. The hound may also hunt francolin,[6] just as the goshawk or the saker hunt hare.

[1] See earlier references to blue eyes. p. 8.

[2] Kushajim 136, adds: "and to the chain".

[3] Kushajim 136, gives this reading with the words "*atfay aslay al-fakhdhayn*", meaning literally "the two pits of the groins"; whereas al-Mansur's book has " *'azmay aslay al-fahkdhayn*", meaning "the two bones of the groins", which does not make much sense.

[4] Al-Ma'mun b. Harun al-Rashid, Abbasid Caliph, died in 833.

[5] See footnote to *al-ayyil* in Part VIII, p. 60.

[6] See footnote to *al-durraj* in Part VIII, p. 95.

Chapter Four

How to feed and build up hounds

From al-Mutawakkili:
Let us speak briefly in this chapter about feeding and building up hounds as this will lead to keeping them safe from the harms to which they are exposed.

We say that in spring and summer they should be fed often because of the length of the day and the heat. They should have bread soaked in cold water[1] in a limited amount because too much makes them vomit: the effect of this is to make them lose weight and change them. If you give them milk on its own or if you feed it to them with the bread, this is good for them.[2] Whatever you feed them, mix with it some crushed cumin as that sweetens their breath and averts the wind. Their first feed should be with cumin, then after that give the rest of their food.

Some of the best food you can give them too is salt cut into strips and whatever water you give them to drink, pour some oil on top. This is what keeps them lean, strengthens them and improves their running.

In autumn and winter they should feed once a day at or near sunset, because when they go out hunting early without having done that, they appear weak, lacking in energy and hungry. Let them eat bread soaked in the gravy of mutton on the bone after it has cooled off.[3] Do not feed them it hot. This makes them ill, when they seem lacking in energy and hanging back from hunting. The broth will correct them, if Allah wills.

How to build them up

If you want to build them up, take some cardamom and cook it in water until it boils. Strain it and throw in as much flour as to fill their stomachs. Feed it to them, if it has cooled, and some bones which have been cooked and broken up. Do this for five or six days. It will cool them down and remove from them any weakness in their muscles. If they are also fed on pig meat with the skin on, that will build them up quickly.

If you take a bull's lung, cook it in water, cut it up and soak it in the water the lung was cooked in and feed it to them, it will build them up quickly. The amount of this that you feed every day should be about 1 lb. This should be enough.

If you feed the cooked lung alone, this will also build them up.

[1] Arrian 8.2 makes a similar recommendation. Mercier 69: the Arabs would feed their hounds once a day on bread lightly spread with fat, just enough so that they did not die of hunger. Bread remains today the staple food.

[2] Xenophon 7.4 advises similarly.

[3] Arrian 8.3 recommends similarly.

If you feed them sheep's heads and trotters cooked with their wool on and give them some of the gravy to drink without any of the bones, this is one of the fastest fatteners.

If you give them about four to five ounces of fat for three days, that will build them up.

If you undertake to feed them these days some Sihriz[1] dates, this will be good.

If they are taken with a strong hunger and are consequently empty-bellied and depressed; and if you want to fill them and build them up without them coming to any harm; take some medicine called al-ha',[2] which you peel, pound and crush, mix with an equal quantity of oil and some salted lard as necessary, and feed it for three days without anything else.

If they do not like the taste of the food, give them some dung, as much as necessary, and pour onto their noses a little water with vinegar mixed with some round cakes of crushed lentils; and this will be good for them.

If they should grow weak from lack of food, feed them some hot fat before their usual time and that is good for them.

If you want to build up cheetahs, give them some meat from legs of mutton, enough to fill them up to a maximum of seven pounds without any fat and this will build them up, if Allah wills.

9. Detail from a Roman mosaic from Bosra, Syria, 2ⁿᵈ century A.D..

[1] This is a type of date and the name derives from the Persian word *sihr* meaning red.
[2] Khayat 192: this is from a plant – *Zollikoferia fallax* or *naudicaulis.*

Chapter Five

Managing hounds and hunting with them

From al-Mutawakkili

It is incumbent on us to follow what we began in chapter four on the nature of feeding and management of hounds - and on the manner of hunting with them if that is really necessary - by bringing in this chapter everything that is needed concerning matters of management and hunting with them in order to complete what we want for their protection against the ills to which they are exposed, the speed of making them tractable and biddable, maintaining the keenness required of them, patience in the field and other necessary things, if Allah wills.

On the places where they are kept and where they sleep and their management there

It is necessary to divide up the places where they are kept, because living close together is one of the reasons leading to bad odours and an increase in diseases, illnesses and mange. So look after them by wiping the paws, combing and rubbing down with something soft such as towels, rags and the like because it is good for them. It makes their skin supple, gives them pleasure and increases their tameness, tractability and obedience when they are required to run fast.[1]

They should sleep in places which are near to their handlers and to people as this makes them friendly as well as sociable and it is good for their smell to smooth out their bedding as this increases their comfort and their energy. Let them out to evacuate their bowels once or twice during the course of the day, because if they are let free the whole day, they become tired and lose their boldness, energy and intelligence. They should not all go out together to empty their bowels but separately. If they have a long rest from hunting, let them out two at a time, so that they are energetic and contented, instead of going out hunting.[2]

On managing them when they go out hunting

It is most necessary that puppies should not go out hunting until after they are ten months old[3] because if they go out before this time they cannot be safe from distorting their bones, knocking themselves and breaking their soft limbs.

They should not be held back from hunting after they have reached this age because if they do not go out after this period you cannot be sure that they will not go off their food and become sick, confused and weak. This will be at the expense

1 Arrian 9.1-3 and 10.1 advises much the same.
2 Arrian 12.1-3 advises much the same.
3 Arrian 25.1 recommends the same but Xenophon 7.6-10. recommends starting bitches at 8 months and dogs at ten months.

of everything in their nature together with whatever they have customarily undergone.

If you go out hunting you should not let a strange hound come near the hounds, because if it did come close this would incite the others to play with it. This would tire them and keep them from their task, because of their respect for it and its strangeness, which makes them feel despondent.

They should go out hunting at day's end in the spring and at daybreak in the summer until it becomes too hot and then let go, because thirst and the heat of the ground are among the most harmful things for their paws and the soles of their feet and this exposes them to burning and to the bad effects of thirst.[1]

In autumn they should go out after the middle of the day and in winter they should hunt in the first hour of the day and, if desired, for the rest of the day, as they will be safe from incurring injury during their long stay in the desert at such time.

As for whether they are good or bad at scenting their prey in the four seasons, their ability to scent might be greatly reduced in the spring not because they cannot reach their prey as their knowledge of their tracks and their resting places is reduced but because the fragrances of the flowers overcome the scents.[2]

As for the summer quarter, their scenting will be very poor because the powerful heat takes away the smells and they can hardly pick up the scent.

In the autumn quarter and the beginning of the winter quarter their sense of smell is sharp, but the hares increase their movements and increase their range in the winter nights. This is why the hounds need a longer distance to track and to scent their prey.

In the winter nights the hares are mixed together with the foxes, especially when the moon shines, and the hounds find therefore both their scents and kill both at that time. They might bark on smelling the scent of their prey but will not do so unless their tracks and their scents are mixed and they are uncertain about whether they have found their right place. They bark when they are at a loss as to whether they should follow and because they fear losing their prey as a result of confusing their tracks and scents.

In the summer quarter, they do not move about so much and their lying up places are closer together because of the shortness of the night. The hounds pick up their scent near at hand and their tracks more quickly.

The best days for going out hunting are cloudless and windless days and they should not go without their leads on because if they are allowed free they will run right and left due to their liveliness and that is one of the reasons for their tiredness and lack of energy before they reach the hunt.

1. Arrian 14.1-2.

2. Xenophon 5 describes the scenting ability of his scenthounds in similar terms and it is questionable whether the descriptions in the following paragraphs are applicable to Saluqis.

They should not go out hunting on windy, stormy days as this prevents them from smelling the scents of the hunt and following the tracks, especially the south wind and rain too, when the scent of the hares goes and their tracks are erased.[1]

They should not go out hunting to places covered with snow after falls of snow because this burns their noses and that way they would be less harmful.[2]

They should not go out hunting after mounting as this is one of the things that reduces their strength and increases change in them.[3]

10. A rare depiction of hawking in the fifth century A.D., detail from a Roman mosaic from Carthage. The combination of hawk and Saluqi mirrors Arab hunting.

They should also avoid being exposed to extreme tiredness and demands on them, which is what upsets them and reduces their energy.

If you go out hunting, you should not urge them on or chide them too much, because that makes them discontented and confused. It is most necessary that you flatter them and call them by their pet names or whatever, so that they will be keen for the hunt, alert, seeking the tracks and working things out.[4]

1 Xenophon 5.3.
2 Xenophon 5.2.
3 Arrian 28.3.
4 Arrian 17.1-2 & 18.1.

Among the signs of their energy when they go out hunting are the joy and good temper that they show, their tail-wagging and alertness, turning their eyes from right to left, sniffing, seeking out the tracks of the prey and their likely resting places and taking in their smells.

It is most necessary when they come near their prey that their handlers should stop where they are according to the activity that they see and that they be nice to them and entice them with words and encouragement so that they should not lose their will to pursue their prey and catch it.

If they are used to hunting in the mountains and are trained to do that, it makes them more keen, toughens their legs and strengthens their sinews.

When they have caught something feed them some of its heart, that will strengthen their keenness and liveliness.[1]

On the diseases to which they are exposed and their treatment

If they should go out hunting in the summer quarter and become tired and if there is no water present in those places and their panting increases, break two eggs in the throat of each hound and their tiredness and thirst will go.[2] If this is not done, beware of the pains of tuberculosis.

Feed them also when they break off from hunting two eggs mixed with sherbet; and this will cool their stomachs and do them good. Or mix some vinegar with water and render in it some lentil flour after it has been pounded and spread it over their backs and necks and sprinkle it on the rest of their bodies. Then break two eggs, drop onto them some oil of roses and make them swallow it, as it is good for them. This lentil flour is soaked in vinegar and poured in their nostrils.

If they should be affected by the heat and their temperature rises as a result, open some of the veins in the ears and let a little blood out, as too much would be harmful to their sight.

1 Mercier, 69: describes the Arab way of training Saluqis in some detail. The young hounds would be started on a fox or jackal with its muzzle secured with a leather strap. They would run after it instinctively and drawing level with it would start to barge into it. When they saw that it did not bite they would become confident and tear it to pieces. They would be fed on some of the innards. See also Hassan, 11-12. Mercier is clearly drawing on experience of N. Africa because he goes on to say that the hounds should be branded with three lines on the inside of their forelegs to keep them from all harm. This is still practised in N. Africa today (vide Clark 2000). However today young hounds are not usually given any special training but learn by running with experienced hounds.
2 Arrian 13.3 & 14.3.

11. A crop-eared Tunisian Saluqi with brands on the forelegs.

If you take some extract called *murri*,[1] as much as necessary, mix it with two eggs and give it via the nose, this will be good for them.

If they exhibit laziness after some improvement, sprinkle also their faces with some vinegar mixed with flour. Then vaporise some hair taken from horses' legs, cover with clothing until they sweat and after that let them rest and give them a rub down.

Take some *Portulaca oleracea*[2] which is said to be sour, pound it, break over it two eggs, mix it with a little fat and feed it to them, as it is good for them. Then pour into the mouth two pounds by weight of old sherbet, more or less as required, mixed with some ground pepper, as this is good for them.

1 Ibn al-Baytar 4/149: this is made from salt fish and salt meat, or from grape juice with aromatics, or clarified honey and bread and this is added to the food to make it palatable. Ahsan 105: *murri* was also used as a spice and was a mixture of pennyroyal (a kind of mint)· ʾlour, salt, cinnamon, saffron and some other aromatic herbs which was made into a dough with rose-water and baked in the sun for forty days.

2 Miller 236: *Portulaca oleracea* was well-known at this period and called *baqlat hamka*. It was described as being mildly constipating, good for the teeth, soothing to ulcers of the stomach, and thirst quenching. It was widely used in medicinal preparations and was also regarded as an anaphrodisiac. It is astringent tasting, hence its being called sour or acid.

If they are constipated and you want to cleanse them, feed them for one day, then take some ground salt and vaporise it as much as required, and hold their noses until they swallow it. If this relaxes their bowels and they are cleansed, pour into their mouths some honey mixed with curds and milk and afterwards return to giving them their food, as this will be good for them.

If you take the fresh stomach of a goat or of a sheep and feed it to them, this will cleanse their stomachs.

If it does not cleanse them, take some *miufasaj*[1] as required, pound it, mix in an egg and two eighths of an ounce of oil, stir briskly and give it via the nose, but aside from its medicinal benefit it is also slimming.

If it is difficult for them to urinate, feed them some dung moistened with goat's milk twice a day and it will make the urine flow abundantly.

If flies sting them, take some rue as required, burn it and mix it with hot water. If the stings were from large blind flies, pour hot water on the bites.

If one hound bites another, take some juniper resin[2] and a piece of slag, mix them and put it on the wound.

If they should be exposed to rabies, which shows itself in their agitation, confusion and rolling eyes, staring at everyone who passes by them, denial of their masters, lack of caution and attention to what is done, and they should bite with such symptoms, take some leaves of rue and pound them, make with it some pounded honey and salt and dress the wound with it.

Also take some leaves of rue and pound them, make with it some oil and vinegar and dress the wound with it.

Or take some dirty wool, wash it and put it on the wound for three days.

Also take some old pig's lard, melt it, boil it and dress the wound with it.

Also take goat's droppings, mix with some old sherbet and dress the wound with it.

If they are out hunting and their paws should become inflamed, take some sand, make a paste of it with honey and put it on the affected places.

If their feet should swell from running or from severe tiredness that afflicts them, take some oil and vinegar, mix them, heat them up, then put it on their feet where they are swollen. If the feet should nevertheless be abraded, make a compress with some wheat flour and water and apply to the places of abrasion on their feet.

Also take some pomegranate skin as required, pound it, mix it with ground salt and vinegar, then put it in a heated earthenware pot and insert their feet after it has become lukewarm and still.

1 Ibn al-Baytar 4/173: from the Persian for mountain berries.
2 Ibn al-Baytar 4/25 & 3/60 and Hava: probably from the Syrian juniper (*Juniperus drupacea*) which is common in Asia Minor. However al-Muʿjam 540 says it is coal-tar.

Otherwise smear the calloused knees with oil, wash with hot water and repeat for three days. Smear on their feet some juniper resin and the abrasions will go. This is effective for their other complaints.

If you put on their necks for three days a collar from the tree that the people of Hamadan call the laur, this will also be good for them.

Also take a gall-nut[1] and a piece of Kerman[2] sulphate of iron, pound them into a fine powder, pour on some wine and vinegar until they disperse it, put it in the sun until it thickens and heats up, then plunge their paws in it, especially for cheetahs.

Chapter Six

Matters to do with hounds' special quality

On treating their eyes for most diseases

What is useful for their eyes against most diseases is to take seven grains of barley and to revolve each one on the sick eye with the left hand until each grain is used up.

On restraining them in kennels

What you can do to restrain them is to take a cane as long as their tails, then shave off the hair of their tails, put it inside the cane and place the hounds under a shelter so that they stay there and are stopped from running away.

Or, stretch out their tails and pluck out as much of the hair as you can. Put it inside the cane and leave it in a place where the hounds are. They will not run away.

Or, take a moist cane and a stone known as amber and hollow out the cane with it afterwards in a place where the hounds are so that they do not see it. The person who does it does not speak until he has completed his task. They will not run away.

On changing their colours

What changes their colour from white to black is to take some quicklime and some silver dross in equal parts, mix them into a paste with honey and smear them with it once a day for thirty days; and they will turn black.

If you want whites to grow black hair, take some shoemaker's sulphate of iron, some squeezed donkey manure and some goat's fat in equal parts, cook them together and smear it on those places where you want the hair to grow. Do this for ten days and it will grow as much as wanted.

Or, take some bread cooked with vinegar and a gall-nut and mix it with water. Then cook it again and smear it on. The white hair will turn black.

1 Khayat 452: this is from the holm oak (*Quercus ilex*) which is found in North Africa.
2 Kerman is a town in central Iran.

On making them longer

If you want to make them longer, dig some holes for them and put some food at the top so that they can see it and their desire for it will urge them to climb out. This is one of the things that will lengthen their structure.

On how to prevent them from running

If you want to prevent them from running, smear their armpits with oil. That is good for them.

On how to kill them

If you want to kill them without them knowing, take three ounces of bull's gall and some medicine known as *kamashir*,[1] six ounces of oleander[2] and silver dross and some fat as required, bring together the medicines, mix them and make into a paste with the fat. Feed it to them and it will kill them.

Chapter Seven

Diseases of the eye, their symptoms and their treatment

Let us begin in this chapter with the treatment of the parts of the body from the topmost, then we follow in the order of their structure until we come to lowest.

Treatment of leucoma in their eyes

If they have leucoma in their eyes, take about a quarter of an ounce of each of bitter salt, some burnt meerschaum[3] and saffron, mix them, pound them, sift them and sprinkle on the leucoma at the beginning and end of the day.

Or, take some honey which has not absorbed any smoke as required, throw in a little crushed saffron, mix well and smear it on the leucoma.

Also take a tiny amount of saffron and meerschaum, pound them and mix them with honey. Then smear the leucoma with it.

1 Steingass 1046: a Persian word for a gum like *Opopomax chironium*, which is taken from the root and was used as a stimulant and in medicine. Ibn al-Baytar 4/77: a dye similar to *O. chironium*, which is very hot and capable of aborting a woman, dissolving or reducing tumours and acting as a diuretic.

2 *Nerium oleander* is known to be poisonous

3 Wehr 372: meerschaum ('sea scum') is a white compact hydrous silicate of magnesia, used for making tobacco pipes.

Treatment of old leucoma

If their eyes should have advanced leucoma, take 1/16 of an ounce of honey, 1/8 of an ounce of saffron, a little over 1/8 of an ounce of bull's gall, a small amount of squeezed mace[1], mix them after pounding and sifting them and smear on the leucoma.

Treatment of running eyes

If they have running eyes, pour out some lukewarm water, take some flour and the whites of eggs in equal parts, mix and smear their eyes with it. It will stop their tears, if Allah wills.

Treatment of cracked eyelids

If they should have cracked eyelids, take two mice, burn them with some dirty wool and some spider's web which has been smoked, put together, pound well and put it on the cracks. If blood should nevertheless flow out of them, take a piece of iron, heat it up, cauterise the places and the blood will cease to flow from their eyelids.

On medicine useful for most diseases of their eyes

It is to take some fresh chicken's mire, mix it with vinegar and spread it on their eyes.

Chapter Eight

Treatment of the ears

If they should have ear trouble, take a dirty sponge, burn it, then pound it and smear it on.

Treatment of swelling of their ears

If their ears should swell, take some pomegranate skin as required, cook with oil and vinegar and, if possible, drop some in their swollen ears and it should cure them: if not, pour some vinegar on the swollen parts.

Also take some ash of the sponge and put it on them, as it will do.

If what we have mentioned does not work, take a piece of iron, heat it and cauterise the parts.

1 Ibn Murad 2/401: *Foeniculum officinalis.*

Treatment of obstructions of the ears

If they should have obstructions of the ears as indicated by tiredness showing in their faces and depression, change of attitude and severe sleeplessness, open a vein in their ears for the blood to come out as much as necessary if they are fat, or if they are lean, take two ounces of rose oil, mix it and inject it into the nose as much as required, when possible three times over three days.

Treatment of ear abscesses

If they should have ear abscesses, take as much nitre as required, heat it, pound it, cook it with honey and vinegar until a third has gone and treat them with it.

Chapter Nine

Throat diseases

If they should have sore throats or uvulas, take an ounce each of honey and melted butter and pour it down them.

From Kushajim's book:
Put in the throat what is cut off from the dog's white dung, collected from thistles.[1]

Treatment of diseases of the lower jaw

If they should have diseases of the lower jaw, take a piece of alum[2] and a piece of baked clay and some silver dross, heat them, pound them, take as much as you need, mix with vinegar and honey and rub on the lower jaw until it bleeds.

Treatment of abscesses on their lower jaws

If they should have an abscess on their lower jaws, take some salt, myrrh,[3] gall-nut, heated paper in equal quantities, pound, mix with vinegar and rub it on the lesions on their lower jaws.

Treatment of bones stuck in their throats

If they should have bones stuck in their throats, pour some oil down them and join their snouts to the upper parts of their necks until they can stand it no more and spit it out.

Khayat 369: a member of the *Carduus* (thistle) family.
Khayat 343: double salts of aluminium and potassium.
Groom 20-21, 1981: *Commiphora myrrha* was used for treating a very wide range of illnesses.

If this is not successful, take some lukewarm water, pour on a little fat and let run down gently. This will loosen the points of the bones and facilitate their ejection, if Allah wills.

Treatment of leeches stuck in their throats
If they should have these, burn some bugs, which are bed bugs, and smoke them out.

Chapter Ten

The treatment of diseases of the abdomen and rabies
From Kushajim's book:
If the hounds are unable to run and are sick in their stomachs, feed them some mill flour mixed to a paste with dill[1] water, given while it is hot.
 Or feed them a piece of bread with ewe's wool made into a paste with fat.

From al-Mutawakkili:
If they suffer from sickness of the stomach and the cause is a worm in it, take some antlers, burn them, pound them, mix with honey and water and feed it to them: will kill whatever they have in their stomachs.
 Take also from a medicine called *sudayun* and from the seeds of the wormwood[2] one part of each, mix with water, filter and inject via the nose as much as necessary.
 Otherwise cook the head of a goat with its hair on until it disintegrates, then take some grit, pound it, and sprinkle it on the head and on the gravy from it. After this feed it in the evening with a little lentils with oil and they will cast out whatever they have in their stomachs.
 If not, then starve them for a day, then take some *burinj*,[3] mix with curds and feed it. After that feed them in the evening with some lentils with oil and they will cast out whatever they have in their stomachs.
 Or feed them with a little henna[4] mixed into a paste, then feed them afterward some wool rubbed with cow's fat.

1 Khayat 343: *Anethum graveolens.*
2 Ibn al-Baytar 1/41: *Artemesia absinthium,* a strongly aromatic plant.
3 Ibn al-Baytar 1/88: *burinj* is the Persian for a small black and white seed imported from China.
4 Miller 190: *Lawsonia inermis* is a shrub growing up to 4 m. tall from the leaves of which the dye henna is obtained. Henna was also widely used for treating a whole range of ailments.

reatment of intestinal diseases

' they suffer from intestinal pain, cover them with a cloth that has been heated by
ιe fire, then boil a head of garlic, mix it with molten tar and oil, make hot with a
ɔated iron and inject it via the nose.

'reatment of diseases of the stomach

' they suffer from a weakness of the stomach, loss of weight or of appetite, bad
ɴells in their abdomen, and diarrhoea, feed them with some cow bones boiled with
ᴠnegar.

reatment of flatulence and wind in the abdomen

' they suffer from flatulence or wind in the abdomen, they should swallow some
ιnegar.

reatment of diseases of the abdomen and flanks

' they suffer in their abdomen or flanks, take a piece of stone from a handmill, heat
ι the fire, put it in a jar, pour on some urine and let them inhale it. Then take after
ιat [some sherbet and vinegar mixed together and rub it over the flanks and what is
ljacent to them, next take after that][1] some cow dung and some medicine called
ιradiq, mix to a paste with vinegar and put it on their flanks and the veins of their
ιdneys.

reatment of abdominal pain called dushantariya (dysentery)

' they suffer from abdominal pain called *dushantariya* (dysentery), feed them some
ιd ewe's cheese and some cooked Turani[2] pigeon as well.

reatment of swelling in the lower parts of their stomachs

' they suffer from swelling in the lower parts of their stomachs, take some thyme[3],
ι much as necessary, cook it with about a pound of oil from unripe olives, mix with
some honey and inject it via the nose as necessary.

reatment of melancholy attributable to rabies

' they suffer from melancholy attributable to rabies, then the way to deal with it is
ɴown from what we described before.[4]

If you want to know the beginning of this disease to take early steps to treat it,
ᴑok at the lower parts of their tongues when they are in a bad humour and you will

All in square brackets is taken from marginalia.
Turan is the name of part of the former Persian empire in Central Asia. However the
entry for pigeon in Part VIII says that Turani pigeon simply means that it is wild.
Wild thyme (*Thymus serpyllum*) is an aromatic.
This refers to a footnote on rabies in Chapter Five.

find a small whitish lump like a worm attached to the roots of their tongues. If this is found, confirm what it is and cut the lump out: they will be improved by this.[1]

If the illness does not leave it, take some roots of the wild rose,[2] pound them into a fine powder and dissolve in hot water, then filter and give them some to drink.

Or take some wild figs,[3] pound into a fine powder, mix with old fat and feed it to them.

Take also some leaves of the plant called *qasus*,[4] a tree without roots, as its branches are like rope and stick to walls and climb up them, pound them and give it them with their food in the early forenoon.

Take also some chicken mire, eight parts of old sherbet and some myrrh as required, mix and make them drink it or feed it to them.

Take also some medicine called *haldunia*, mix with old fat and bread and feed it to them.

Treatment of diseases which cause blood in the urine
If they should catch some diseases which cause blood in the urine, take about two pounds of lentils, cook with curds and the juice of moist coriander,[5] throw in about 25 grains of pounded and sifted pepper, pour on some oil as necessary and feed it to them or inject it via the nose.

How to purge them
If you want to purge them, let them drink some goat's milk and anoint their navels with bull's gall.

Or take some freshwater crabs, crush them, mix with water and let them drink of it as much as they want.

1 Grattius 384-398 also refers to such a worm under the tongue.
2 Probably the dog rose (*Rosa canina*).
3 *Ficus carica.*
4 Ivy (*Hedera helix*).
5 Coriander (*Coriandrum sativum*) the seeds of which are aromatic.

Chapter Eleven

The treatment of wounds and cuts to their limbs

From al-Mutawakkili:
If they should have these, take some baked clay, put it in the fire until it is hot, then pound it with some pungent vinegar; follow the places of the wounds and pour it over them.

Also take some garlic, honey and pungent vinegar, put together, mix until about a third has gone, then smear it on the wounds and cuts. After that take some dried pomegranate skins, pound and sprinkle it on.

Also, take some gum of the turpentine-tree[1] and some goose fat, mix and put on these places.

Treatment of worms in their wounds

If they should have worms in their wounds, pour on some vinegar mixed with water, then take some quicklime and molten tar in equal amounts, mix together and smear it on these parts.

If you do not know where the wounds are located in their bodies, let them stand in the sun and it will indicate where the places are. Then pour on some hot water, take some cow dung as required, mix with vinegar mixed with hot water and pour over these places.

Treatment of old wounds

If they have an advanced wound and it is necessary that the new, healthy muscle should grow quickly, take iris[2] roots, bitter vetch,[3] and roots of *Opopanax chironium* in equal parts, put them together, pound to a fine powder and sprinkle on the wound.

Also take some fresh oil and pour it over these places.

1 *Pistacia terebinthus.*
2 Possibly one of the *Pancratium* genus which was used extensively in early medicine.
3 Ibn Murad 2/665: *Vicia ervillia.*

Chapter Twelve

On the treatment of swellings, ulcers, abscesses, verrucas and surface tumours appearing on their bodies

From al-Mutawakkili:
If they should have swellings on their bodies after an abscess or a wound or something similar, cook in water as much as possible of the tips of tree branches and pour it over their entire bodies. If any of the swelling should remain, take some honey and some clarified butter in equal parts, mix and let them lap it.

Treatment of swellings without abscesses
If they should have swellings without abscesses, take some meerschaum, burn it, pound it, take some of the ash while hot and smear it on the places of the swellings.

If their bodies should swell up and come out in a shiny red spot which is repeated elsewhere on their bodies, take two ounces of each of galbanum,[1] storax,[2] deer's brains and oil and three ounces of bitter salt, put together, pound as much as possible, cook and when it has mixed thoroughly and melted, rub over their loins for 10 days and let them sip some a little at a time.

Treatment of abscesses which are called pimples if they appear on their bodies
If they should have abscesses which are called pimples, take some sappy cane, rub the abscesses with it, wash with vinegar mixed with water, then take some lead dross and some of the medicine known as *kamashir*[3] and some sheets of paper in equal parts, put this all together, burn, pound and sprinkle as necessary on the affected places.

Treatment of abscesses elsewhere on their bodies
If they should have abscesses on other parts of their bodies, especially if they are circular, take some dust moistened with mule's urine and spread it on the affected places.

Treatment of ulcers elsewhere on their bodies
If they should have ulcers elsewhere on their bodies, especially if they are circular, take some dried dung, marrow peelings and some barley, burn each separately, then take a little from each, mix, pound and smear over the affected places.

1 Ibn al-Baytar 3/37: a bitter odorous gum resin obtained from a Persian species of *Ferula*, especially *Ferula galbaniflua.*
2 Ibn al-Baytar 1/39, *Styrax oficinalis.* Miller 160: it was one of the ingredients for making incense.
3 See footnote to Chapter Six.

Treatment of verrucas

If they should have verrucas and something like glands, rub the affected places, then smear with hot fat and if they become soft, take some dried pomegranate skins and salt in equal parts, mix after pounding, sieve with vinegar and oil, then smear the affected parts while it is hot.

Also take some aloe[1] and mustard[2] in equal amounts, mix, pound and spread them as necessary over the affected places and they will open them up and heal them.

When they open up, take some sugar beet[3] and some leaves of the Egyptian willow,[4] boil, throw in some iron dross as necessary and rub the liquid on.

Treatment of pustules

If they should have pustules,[5] take in equal parts some Persian leeks, pepper, whole eggs, pounded baked clay, old sherbet, honey, and clarified butter, pound what can be pounded, mix well with some wild artichoke[6] and spread the sediment on the places affected by the disease.

Also, take 20 grains of pepper, pound, make into a paste with honey, thin and administer via the nose.

Treatment of the abscess known as scrofula

If they should have this, take twenty grains of pepper, an ounce of clarified butter, some wormwood as necessary, pound, sieve and give it to them with their food as necessary.

Also, take some best quality grain, dry coriander and pepper in equal amounts, pound, mix with sherbet and feed it to them with their food.

Also, take some antlers, burn, pound into a fine powder, mix with water as necessary and administer via the nose.

1 Miller 183: the *Aloe*, of which there are several species, is a succulent plant the juice of which was widely used in medicines.
2 Khayat 200, possibly the white mustard (*Sinapis alba*).
3 Ibn Murad 2/404: *Beta vulgaris*.
4 Khayat 124:*Salix aegyptica*.
5 *Al-jadari* is the common word for smallpox, to which dogs are however not susceptible. Here the editor has vowelled it as *al-jidri* which Lane 707 interprets as pustules.
6 Possibly the Jerusalem artichoke (*Helianthus tuberosus*).

Chapter Thirteen

On the treatment of mange

From al-Mutawakkili:
If they should suffer from mange, tie them out in the sun on a hot day[1] when two hours of the day have passed and smear them with oil; then take some medicine called *kamashir,*[2] pound it, sprinkle it on the mangy place and leave them be for a whole day; then put them in the bath and wash them with luke warm water.[3] When they return to their normal places, wash them also in as hot water as possible and when dry smear them with oil. Then sprinkle on them some of the pounded medicine; and this is done for three days.

Take also a half portion of arsenic, and one portion of dittander,[4]sulphur and wax, pound what can be pounded, cook in oil and put in a pot. Then wash well the mangy places with water and when they are dry pour on some of the medicine as necessary and put them out in the sun for the rest of the day. This is done for three days on alternate days.

Take also one portion each of the white from its dung and some coarsely ground salt, mix, pour on some naphtha as necessary, boil in a pot and rub on the mangy places. Tie them out in the sun for the whole day; and this is done for three days.

Take also equal parts of carbonate of lead, resin of the cedar tree,[5] gum of the turpentine-tree, cow suet, fat and the tincture of the odoriferous rush,[6] then mix and put on the fire; when hot rub on the mangy places.

If they should get the mange and the hair should fall out from the mangy places; and if you want it to grow again; take some lily roots as necessary, mix with bear's fat until it becomes like honey and rub it on those places.

If abscesses and ulcers like warts should appear, bind the abscesses and warts with horsehair and they will fall off.

Ulcers are treated in the way we described in the chapter on ulcers.

1 Grattius 420-424 and Nemesianus 201.
2 See footnote 1, p. 37.
3 Grattius 415 recommends "doses of bitumen, mixed with fragrant wine and portions of Bruttian pitch and ointment from the unregarded dregs of olive oil", with which the hounds are bathed. While Nemesianus 201 says: "to blend tart draughts of wine with Minerva's olive-fruit and it will do good to anoint the whelps and the mother dogs, expose them to warm sun and expel worms from their ears with the glittering knife".
4 Khayat 444, *Lepidium latifolium.* Fitter 92, a plant resembling the horse radish.
5 This is more likely to be the Atlas or Algerian cedar (*Cedrus atlantica*) which is found in the mountains of Morocco and Algeria than the cedar of Lebanon (*Cedrus libani*).
6 Possibly one of the *Cyperaceae* family. Miller 124 : the species *Cyperus* was widely used in medieval Arabic medicine.

When cheetahs in particular are affected by mange, spread sand in their pens to clean their hair, for if not something will afflict them, because they catch this disease as a result of their urine which comes in contact with their bodies.

Chapter Fourteen

On the treatment of the joints and limbs

From al-Mutawakkili:
If they should be so affected, take some pounded gall-nut as required, cook with water, rub it on and after that bandage their joints with some barley flour. The problem is in pains in their limbs which prevent their movement, like paralysis and similar, so cut a vein in their ears and bleed them on two successive days as necessary.

Treatment of cut veins in some of their limbs

If they should cut veins in some of their limbs, take some leeches and burn them, then take some of the ash as required, mix into a paste with honey, bandage it on and they will be healed if Allah wills.

Treatment of gout

From the book of Kushajim:
They have abrasions of the feet because the limbs are weak and body liquids flow to them.

The remedy for it is to smear the forefeet and hind feet with vinegar and oil or to put some resin on them or to take a piece of gall-nut and some sulphate of iron, pound, cover with wine, put in the sun or on a gentle fire until it thickens, then dip the hound's paw into it when it is lukewarm.

Chapter Fifteen

On the treatment of diseases of the hindquarters

From al-Mutawakkili:
If they should have such diseases, take some sprigs from various trees, cook them in water and rub that water on their hindquarters when possible. After that take some old oil and some old fat in equal amounts, put on the fire and when mixed, anoint them with it.

If there are ulcers in the neck of the anus, cover with pieces of cloth to protect them from the air, then take two cloves of garlic, pound, mix well with oil, then put it there; and inject it in stages via the nose: for this take twenty grains of pepper and three laurel[1] berries, pound well, put some clarified butter with it as required, heat up well an iron, insert it into this medicine, stir until mixed, heat and inject via the nose when possible.

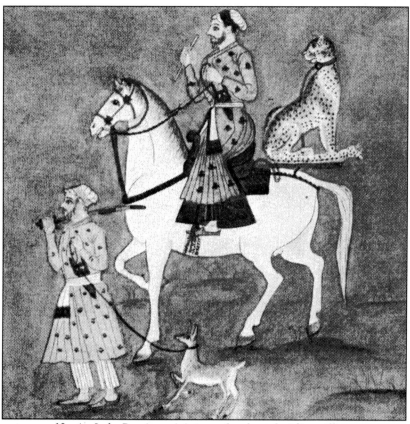

12. An Indo-Persian miniature of a cheetah riding pillion.

1 Khayat 487, the sweet bay or poet's laurel (*Laurus nobilis*).

Chapter Sixteen

The characteristics of cheetahs

According to Kushajim:
The cheetah is a beast of prey that excites the large beasts of prey, which seek where it is located and enjoy its meat greatly.

It is hunted in various ways: by a beautiful voice to which it pays attention if it hears it well.[1]

Another way is by tiring it until its paws are sore.[2] When it is taken, cover its eyes and put it in a sack. So long as it is wild, keep it in a small room and put a harness around its head.[3] A handler should stay with it night and day and prevent it from seeing the outside world. He should make for it a saddle like on the back of a donkey and train it to ride on it. He should feed it by hand, trying steadily all the time to tame it. If the cheetah can eventually ride on its back, it has become tame and ready to hunt.[4]

Wise men say it is one of the wildest animals but it may be tamed through familiarity.

It is said that it is born of a lion and a tigress and of a lioness and a tiger.[5]

There are different ways of hunting with it, among which are: by force, stealth and tracking.

1 Viré *E.I. Fahd* 741: it was believed that the cheetah like some other animals could be charmed by music and singing.

2 Viré *E.I. Fahd* 741: a mature cheetah, preferably a female, would be pursued in the heat of the day by two men mounted on horseback, who would give the beast no rest until it was so tired that a cover could be thrown over it and its limbs bound.

3 Viré *E.I. Fahd* 741: the practice was to put the cheetah in a kind of straight-jacket with only its head free and to put over its head a leather visor shaped like a baby's bonnet and tied under its chin.

4 Viré *E.I. Fahd* 741: the important part of the training was to accustom the cheetah to ride pillion. The trainer would make a dummy horse and train the cheetah to jump on it in return for rewards of food. By dint of daily training the cheetah learns to look for its food on the dummy horse's back. The exercise is then shifted to a suspended platform and the cheetah learns to seek its food while balancing on the rocking board as if it were on the back of a horse. Then the training continues on the back of a real horse until it is ready to ride behind its keeper, untied except for its slip which is knotted to the saddle bow.

5 Aristotle 607a2 and Pliny 8.61.148 mention crossbreeding between species, eg wolf and dog, fox and dog to produce Laconian hounds, tiger and dog to produce Indian hounds, but they do not include cheetahs. Herodotus 1.192 & 7.187: Indian hounds were kept by the Governor of Babylon in the early 5th century BC for hunting onager, gazelle, deer and lynx.

As for force, if it meets a herd of gazelle face to face and the buck leading it is confronted by your cheetah until it is close, let it go for it and that is the hunt of kings in which there is an element of superiority.[1]

As for stealth, if you put the cheetah down from the saddle after it has seen the gazelle and you continue on your mount as if you do not intend to go towards them, your cheetah will creep towards them unseen until it is near and can leap on them.[2]

As for tracking, if the gazelle are widespread and you come on their tracks, slip the cheetah on them. This is the method mainly used and is less tiring. This is the hunt of merchants.[3]

If the cheetah leaps on its prey, it will not breath until it has secured it.[4] This causes it to heat up and its lungs are full of the air which it held in. The thing to do is to let it rest while it expels the air and cools down. A piece of the heart of its prey is cut off for it and it eats it. If it is summer it is given some water or, if it is cold, no water. Then it runs again, but it should not run more than ten courses, though it could hunt twenty times with difficulty. If it does not rest after that it will not be successful.

It is by nature shy, sleeps long and is bad-tempered. It is not known whether it covers[5] its mate in the hands of people. It has been tried hard but unsuccessfully. If you stroke the male and female over the whole of their bodies they are quiet until your hand reaches their mouth, when they are inclined to bite.[6]

Their nature is similar to the nature of hounds, even as regards their illnesses and remedies.

It seems that the excellence of its hunting by stealth comes from its cunning, concealing its bell and making itself small. It is slipped on its prey from a distance after it has spotted it. It is calmed in order to be released without concern and it sets

1 Viré *E.I. Fahd* 742: the huntsman would split off a buck from the herd and run it down to the point of exhaustion, whereupon the cheetah is slipped to finish it off. This requires great endurance and skill from riders and mounts alike.

2 Viré *E.I. Fahd* 742: stalking is a thrilling spectacle. The keeper unhoods the cheetah which makes its way upwind to try and take the gazelle by surprise, using every undulation of the ground until it is close enough to make the final charge.

3 Viré *E.I. Fahd* 742: here the cheetah trails the whole herd and may be able to lay several low before they are able to escape.

4 Kingdon 287: the structure of the cheetah's skull is however designed to enable it to continue breathing by panting through its exceptionally large nasal passages, while it maintains its throttle grip on its prey for up to 20 minutes until it has suffocated it.

5 Kushajim 185: gives *'aazala,* which is normally used for the coupling of dogs, rather than al-Mansur's *'aadala,* which does not fit here.

6 Kushajim 185: gives this reading, with "*thaghr*" for mouth, where al-Mansur gives "*thafr*" (crupper) and "*tan'atifu 'alayhi lita'udda*" instead of "*fataqlaqu wa ta'uddu*" (when they become excited and bite).

off like a weasel raising first one foot and then the other[1] as long as its prey is feeding. If it is afraid the prey might escape, it presses ahead by itself in such a determined way, as the poet[2] said, that it went on and would not even spit out the bitter cucumber.[3]

This kind of gait is called stealthy and a horse's is similar. They say in Arabic: *'ad'a y'adu.*

They say that the wolf approaches the gazelle stealthily to eat it.

They say that if its blood is mixed with *Memecylon tinctorium*[4] and the vinegar of the lily[5] and is smeared on a foot with gout the pain will diminish.

Chapter Seventeen

The treatment of cheetahs

They have such complaints as weakness of the legs, abrasion of the feet and mange.

The weakness of the legs comes from rickets in the legs. The remedy is to feed meat occasionally with a little cow's melted butter and honey.

Or, take some pounded safflower[6] seed and cook until it froths, filter and mix three ounces of it. Throw on half an ounce of a kind of sweetmeat called *fanid*[7] and administer as an enema.

The mange comes from its urine and the way to solve this is to spread a layer of sand on which it urinates to avoid any urine coming in contact with it body. Sand also cleanses its hair.

The remedy for mange is crushed white sulphur boiled with oil, heated on the fire and rubbed on it.

The remedy for abrasion of the feet is the same as we described for canine abrasions.

It is mainly used for hunting gazelle.

1 Cheetahs, like Saluqis, will stalk their prey and tread very carefully while keeping their head thrust forward in a line with their back and their eyes unwaveringly on their prey.

2 A famous Bedouin poet, Ru'ya b. al-'Ajjaj, who died about 709.

3 Miller 120, *Citrullus colocynthis* is of the water melon family but grows wild in desert areas. Its fruit is bitter and has been used in medicinal preparations since ancient times.

4 Miller 152: a desert plant yielding a juice used for making a yellow dye.

5 Ibn al-Baytar 3/183 describes *'unsul* as a kind of wild onion. However Lipscombe 47 uses the Arabic word *'unsulan* to describe the wild iris in Saudi Arabia.

6 Fitter 248: the safflower (*Carthamus tinctorius*) or bastard saffron is a thistle-like plant with orange flowers, yielding a dye.

7 *Fanid* is made with sugar, flour and Persian manna, a sweet exudation from a species of ash, chiefly *Fraxinus ornus* or from tamarisk (*Tamarix gallica*).

From al-Mutawakkili:
A weakness affects their legs and they become ulcerous from it. The treatment is to feed them meat smeared with melted butter and honey three times a day for three alternate days. Then give them an enema of cow's or sheep's yoghurt with some honey.

Also, take some white sulphur as required, put it in a pot on the fire, melt with oil and pour it over the affected places once or twice. This is good for them.

Chapter Eighteen

The caracal and the weasel

According to Kushajim:
The caracal[1] is a beast of prey.[2] They call it in Arabic *al-tuffah*[3] as in the saying: because of the caracal he no longer needs the straw: the latter is of no use. It has a special role in hunting the crane and other similar birds, which it takes very well.[4]

As for the weasel,[5] it is one of the predators and hunting with it is allowed.[6] It hunts the fox well. It is entered to it with a rope round its neck, then it is pulled back with it from its den.[7]

1 Kingdon 281: the caracal (*Felis caracal*) is a lynx which is still widespread across North Africa in spite of being rarely seen.
2 This means that it is lawful for Muslims to eat what it catches.
3 Viré *E.I. Fahd* 739: this is apparently the name given to the jungle cat (*Felis chaus*) which was once common along the rivers of Iraq and northern Syria and also found in scattered populations from Egypt to Asia Minor.
4 Harrison 164-5: its colour is admirably suited to the arid hilly steppe country and mountain terrain across the region and its great jumping powers enable it to catch birds on the wing. Its speed is greater than that of most cats of its size and it was formerly trained for hunting small game, like the cheetah. Ahsan 210: it was perhaps one of the most popular beasts of prey. Light and undemanding it was used for "fur hunting" as well as for catching such birds as partridges, wild geese, bustards and cranes, usually by stalking.
5 Kingdon 229: possibly *Mustela nivalis numidica* which is common across North Africa Or, *vide* Viré *E.I. Fahd* 739, as a trained animal, it might even be the ferret (*Mustela putorius furo*).
6 Allowed by the Qur'an as a trained predator – Sura V 4/5.
7 Viré *E.I. Ibn 'Irs* 808-9: 'Isa b. 'Ali al-Asadi (13th century) in *Kitab al-Jamhara f. 'ulam al-bayzara* (unpub.) specifies that in the 13th century in Baghdad the weasel was the indispensable aid in hunting wheatear (*fuqaq*) with the merlin (*yu'yu'*), for these little birds at the sight of the falcon darted into thorn bushes and only on the appearance of the weasel held on a leash were they forced to fly out. The weasel was also used to dislodge the fox from its earth. It either fled in terror or if the weasel had seized it by the throat it could be pulled out as the weasel would never let go.

Its flesh cures epilepsy at the beginning of the crescent moon.

It is said that it can kill the crocodile. For this purpose it enters its stomach after it has wallowed in mud to make its fur stand on end when it is shaken or blown by the wind and it eats its liver. It fights snakes.[1] Sometimes they coil around it and when it feels that it hurries to the fire and both of them burn.

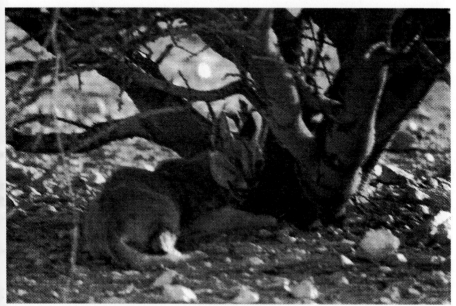

13. Caracal in Oman

1 Oppian 3.406-32, attributes this method of killing crocodiles to the ichneumon (*Herpestes ichneumon*) or Egyptian mongoose and it is more probable that it is the mongoose rather than the weasel that is intended here, especially in view of its ability to fight snakes, though the story itself belongs to Greek realms of fantasy.

Chapter Nineteen
ON HUNTING WITHOUT ANIMALS

14. Sagittarius from a 13th / 14th century illustration of the constellation by al-Qazwini.

Hunting with bow and arrows
According to Kushajim:
We begin with a reference to the instrument of shooting and a description of its careful use.

The best arrow is the new wooden one which kills on the spot and is the most penetrative. The best one has pliant feathering. If you fear rain will fall on it, bind it round with some string.

The bow-strings stretch in the rain and the dew, especially leather ones, and they shrink when it is hot and dry and the land is arid.

The helpful precaution is to have two strings, one long and one short and to string each of them at the appropriate time. If you only have one with you, make it an intermediate one. In case you should need to shorten it tie a knot or twist it once or twice as required. In summer or during the hot winds keep it in a cool place. A short string is less damaging than a long one on the bow, because if it is long it loses its tension and misses its aim.

Sinew is best for the soft, medium and other bows and leather is best for the hard.

Silk is best for winter because it does not slacken in the rain and the wet.

The best strings are those whose threads are constant all the time and do not change.

The best of the knots are the smallest - with a ring for a knot on the right and a ring for a knot on the left -and if it becomes short it does not connect.

It is said that if the string at the lower ring is shortened it is faster for the arrow.

Chinese fat on the bow protects against the dew and the hot wind and preserves it.

The right amount as far as the span of the bow is concerned should be the length of the arrow from base to head measured between the two ends of the bow.[1] If it is less it will be difficult to draw and defective; and if it is more the arrow will overshoot. The length of the arrow depends on the strength of the archer's draw and the length of his pull.

It is best to grasp the arrow with three fingers - the middle, little and ring, which is stronger than with the index finger and thumb. The index finger locks on the arrow.

The best pull is achieved when the arrow is fitted in the string by pulling the string not the arrow. The pull with three fingers is called by the Arabs al-*daniyyat* indicating the three lower fingers and al-*bazm* with two fingers.

Shooting by night requires you to put your eye by your left hand, your right hand by your shoulder and the string by your ear. Whenever something comes near, shoot at once.

Shooting by day is by chasing, if you want to go towards the prey and do not intend to shoot anything by turning around and looking back, but keep going after it.

The best place for shooting the animal is between the shoulders and the breast next to the heart, where it quivers from the beating of the heart. This is called al-*farisa* in Arabic.

When you come near it, shoot!

Aim the arrow at the animal's forequarters towards its face. If the arrow reaches that place, it may move forward and the arrow will strike the intestines; and it may struggle on with whatever arrows may have hit it.

This is commendable in shooting.

If you aim the arrow ahead of it, it hits its forequarters. Be careful not to shoot it, while the hound is on its track, for if you aim at its hindquarters you will hit your hound and pierce it. Thus you would emulate ibn Sulaiman who was out hunting with al-Mahdi[2] and Abu Dulamah.[3] A gazelle appeared before them and al-Mahdi shot at it, hit it and pierced it with his arrow. 'Ali shot at another and hit his hound and killed it. Abu Dalamah recited:

1 The full length arrow is about 72 cm. (c. 26") which equals approximately the length of the 'working' limbs of a composite bow (not including the grip and the 'ears'): A.G. Gredland, Chairman, Society of Archer-Antiquaries in private correspondence.

2 Al-Mahdi Abu Abdallah b. al-Mansur, the third Abbasid Caliph, who succeeded in 775 and died in 785.

3 Zaid b. al-Jun, a black from Kufa, a raconteur of mysteries and stories, he grew up under the last Umayyad Caliph and reached prominence under the Abbasids.

Al-Mahdi shot at a gazelle and the point of his arrow pierced its heart.

'Ali bin Sulaiman shot at a dog and killed it.

Congratulations to them both, to each his own food!

Because of this, put on the chariot[1] for learning how to shoot a hare at the front and a dog at the rear.

The Arabs say: when the arrow is effective: *rama fa asma* -he shot and killed on the spot or *rama fa aq'asa* -he shot and killed immediately or *rama fa amkhata* - he shot a penetrating arrow. They also say: *rama fa anzara* -he shot and was in a hurry.

When it fails, they say: *rama fa asrada* -he shot and *rama fa ashwa* -he missed or he shot and did not kill, if it hit a non-vital part such as the legs.

Al-isma (killing on the spot) is when you shoot and kill immediately. *Al-inma* (hitting and wounding) is when you shoot but it keeps on going.

They say: *safa* (it missed) when the arrow deviates from the target and from this is taken the word *al-sayf* (miss).

They say of the arrow that is aimed at one thing but hits another, that it is a random (*'arad*) arrow or a deviating (*gharab*) arrow.

They say about the possibility of shooting: *'akthabaka* (the hunt has come within your reach) and *'afqaraka* (you were able to hit it in its back), when it is close to you and you are able to hit it in the spine; and *'a'arada* (it has come within reach) if you are able to hit it in its side it.

About shooting with pellets (*julahiq*)

According to Kushajim:

The Arabs do not know this word (*julahiq*),[2] though such bows were used for shooting in the days of 'Uthman,[1] Allah be pleased with him, and they complained

1 Ahsan 223: archers were trained by means of a moving target known as 'imitation beast on a chariot'. The skin of a hare stuffed with straw, representing the prey to be shot, was tied to the front and another stuffed skin, representing the hunter's hound, was tied to the rear. The chariot was then pushed down a steep incline and the archer's objective was to hit the front skin. Alternatively a rider on horseback pulled the chariot behind him on a long rope.

2 Steingass: lists *julahiq* as a word of Arab origin, meaning a ball thrown by a ballista. However the *Loghatnameh* of Dekhoda gives more appropriately under *jolah* or *joleh* a stone bow. Store 256 & fig.315 has an entry for stone bow but also lists under *gulail*, also written *golail, ghulel* or most commonly *gulel* – the Indian pellet bow. In personal discussion Professor Richard Holmes, the military historian, related that in Pakistan he had seen such bows, fitted with a divided string in which a stone or lead ball or pellet can be lodged. Store 256: at the instant of shooting the bow must be moved to the left or the pellet will hit the thumb with painful results! T. Richardson at the Royal Armouries noted in personal correspondence that such bows were widely used from China across India to Persia.

about them to him. It was said that they killed the people's pigeons, so he forbade that in the buildings of the Sanctuary[2] but did not forbid it otherwise.

They were capable of very accurate shooting and could even hit the limb of the bird exactly.[3]

It is said that two hunters from Basra met a lion and one said to the other: I shall be content with one of its eyes so that I may make you content with the other. They both fired together, blinded it and were saved.

15. Neshmi the archer pulling a pellet-bow,
drawing from a Persian miniature of the early
17th century by A.G. Credland.

1 Bosworth 3-4: 'Uthman b. 'Affan, the Prophet's son-in-law, who was elected Caliph in 644 and ruled until he was assassinated in a rebellion by discontented elements in 656.

2 Kushajim 247: makes it clear that this is al-*haram al-sharif* at Mecca, whose pigeons were famous throughout Islam – Rentz, *E.I.* 541

3 Professor Holmes (see n. 2, p. 56) also remarked on the accuracy and efficacy of the pellet-bow for shooting birds out of trees, where a pointed arrow might stick into the wood, losing the arrow and possibly the transfixed bird. The sharp-pointed arrow tears and lacerates the flesh, whereas the ball strikes a crushing blow without piercing the skin, Credland 1975, 15

About trapping with bird-lime

According to Kushajim:

It is impossible to do except where you can fix a cane with the bird-lime onto the branches. Only sparrows, serins,[1] starlings, other similar small birds, types of nightingales and whistling birds become stuck on it. It is more enjoyable than trapping with nets and safer for the birds as the nets break their limbs.

1 Ahsan 225: *Serinus serinus* is resident in N. Africa, the Syrian or Tristram's serin (*Serinus syriacus*) is resident in Syria and the red-fronted serin *(Serinus pusillus)* is found in Iraq.

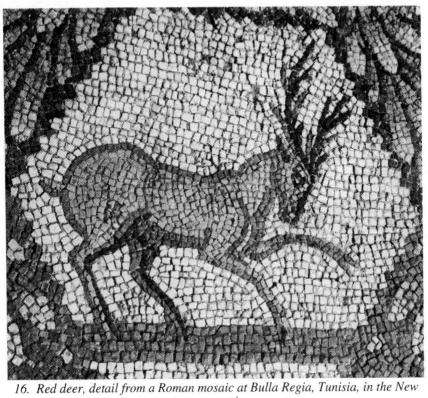

*16. Red deer, detail from a Roman mosaic at Bulla Regia, Tunisia, in the New
House of Hunting, 2nd century A.D.*

Part VIII

Prey

From Kushajim's book:

Mountain goat (*al-ayyil*)[1]

It has sharp-pointed weapons in its horns. It rarely comes down to the plain and stays in the mountains. Its horns are solid and not hollow inside. The horns of other animals are hollow. It does not shed its horns and replace them; whereas others shed them once a year. It begins to grow horns after the elapse of two years from its birth. It has four teeth on one side of its mouth and four on the other.

What is strange about it is that the buck is all sinew and no meat and that the blood of every other animal coagulates except for its blood. Its flesh is coarse[2] tending towards black bile.[3] [The doe does not have horns. The bucks have louder voices and are like bulls when they mount.[4]] The does become very restless when

1 It is not at all apparent what animal is described here., partly because the al-Mansur text differs significantly from Kushajim's. Kushajim 143: says that the *ayyil* does shed its horns annually, which would make it of the deer family. Kingdon 338-9: red deer (*Cervus elephus*) are now found only in the Medjerda Mountains on the Algeria-Tunisia border. However they are thought to represent a stock that has occupied N.W. Africa uninterruptedly since the Pleistocene. They were probably quite common in Roman times, judging by the frequency with which they appear in mosaics from the region. Harrison 204-7: another possibility is the Mesopotamian deer (*Dama mesopotamica*) which once had a range that included Iraq and Iran, and northern Arabia. Harrison 207-10: the roe deer (*Capreolus capreolus*) was formerly widespread in northern Iraq. However if we take the al-Mansur text as it stands *al-ayyil* cannot be deer. Allen 132: *ayyil* is the oryx in early Arabic poetry but this is clearly not the case here as it is a mountain creature; whereas the oryx is an inhabitant of the desert (see separate entry below). Jayakar translates al-Damiri's entry for *ayyil* (vol. 11, 222) as Bezoar goat (*Capra aegagrus*), which produces in its stomach the bezoar (Arabic- *bazahr*, see *E.I.* 1155-6) stone used as an antidote to poison. Harrison 183-5: this is the mountain goat, which once was found across northern Syria and Iraq. This could well be what is intended in view of the description of its horns, which are not shed annually and the females have markedly smaller horns than those of the males. Kopf, *E.I. Ayyil* 795, also favours mountain goat.

2 Allen 141: *ghaliz*, the word used here, means well-muscled, at least when applied to a Saluqi.

3 *Kimus al-sawda'* in Arabic which is a direct borrowing from the Greek *melas khymos.*

4 The words between square brackets are taken from the margin of the book and misrepresent the females which do indeed have horns, albeit smaller than those of the males.

the bucks mount; yet they accept the semen walking or running. They like to hear singing.[1] The bucks eat snakes which do not harm them.

If you use the smoke from its horn burnt with red sulphur or its blood with chick pea flour, snakes go away.[2]

The smoke from its burnt horn when administered to a pregnant woman helps her to give birth. The hound might hang on to it but can only rarely overcome it unless two or three of them get together against it and frighten it. It does not escape by running away but by its weapon. They are afraid of its horns.

Onager or Wild Ass (*himar al-wahsh*)[3]

It is the donkey (*al-himar*), the wild ass (*al-mishal*), the wild or domesticated ass (*al-'air*), the onager (*al-jaab*) and the wild ass (*al-fara*). The Prophet Muhammad said: the most sought after prey is in the belly of the wild ass. The female is called she ass (*al-'atan*) which is called *la'* when pregnant and *nahus* when it is unable to conceive. Its offspring is the young ass (*al-tawlab*) and a group of them is called a herd (*al-'aana*).

It makes a braying noise (*al-nahiq, al-shahih, al-sahil*). It does not mount until it is thirty months old and is not fertile until it is three years old: some say: two and a half years. It is described as very protective.

The Arabs maintain that when a colt is born its penis is bitten off to geld it.

They maintain that the she ass makes a deception by running away when she has dropped the colt until it is safe.

Its meat

The wild ass is most praised for its meat.[4] The meat of the old one produces bad blood. Once you bite into it you cannot cure your desire for eating it. Its navel is the best part of it.

Many people eat ass scalded and roasted. They like its skin grilled and consider the taste is like the meat of the hedgehog.

Its fat is useful for red patches on the face if anointed with it and for pain in the back and kidneys arising from phlegm.

It is not caught with hunting hounds or falcons except eagles as we mentioned in the relevant chapter.[1] It can tire your mare,[2] so if you approach it, spear it; and arrows will hit it in the hunt and double-pointed spearheads will hamstring it.

1 Aristotle *HA* 611b26–8: "When hunted the deer are caught by pipe playing and singing so that the pleasure of it makes them lie down". Pliny 8.50.114: "They can be charmed by a shepherd's pipe and by song".
2 Pliny 8.50.119.
3 *Equus asinus africanus.*
4 Xenophon, *An.* 1.5.2-3 says: "The flesh of those that were caught was very like venison, only more tender".

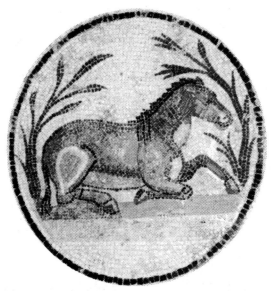

17. An onager, detail from a Roman mosaic, El Djem, Tunisia.

18. A Saluqi attacking an onager, detail of a fresco from Qasr al-Amra, Jordan

1 The frieze on the vaulted roof at the entrance to the Umayyad Qasr al-'Amra in Jordan clearly shows packs of Saluqis hunting onager, see fig. 18.

2 Xenophon, *An.* 1.5.2-3 says that they run much faster than horses and can be caught only by stationing horses at intervals and hunting in relays.

If its hoof is burnt and pounded with antimony it is useful for night blindness and for alleviating pain in the eye.

If you mix its dung with brains and you spread on the forehead it stops nose bleeds.

It is said that if a ring is cut from its hoof and is hung on the person who suffers from epilepsy, it is useful.

Its brains mixed with the juice of the wild celery[1] and honey and boiled, if poured on someone with consumption with hot water before breakfast, he will recover.

Oryx (*baqr al-wahsh*)[2]

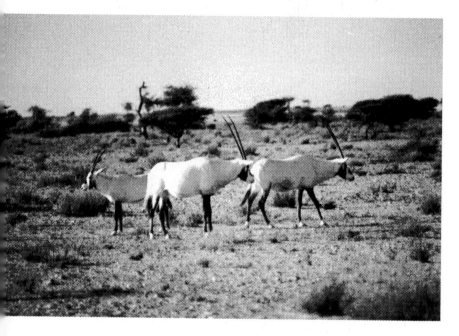

19. Arabian oryx on the Jiddat al-Harasis, Oman.

Khayat 580, *Apium graveolens*.

It is not clear whether this is the North African scimitar-horned oryx (*Oryx dammah*) or the Arabian oryx (*Oryx leucoryx*). Viré *E.I. Mahat* 1227-3, it could also be the addax (*Addax nasomaculatus*), which is found in N. Africa and was previously found in Palestine and Arabia. It has long straight horns but differes from the oryx in the absence of brownish-red markings on the neck and breast. It has a brown forehead.

The Arabs say that the first person to hunt it on horseback was Rabi'a b. Nizar b. Mu'add[1] and when he mounted his mare and ran after the oryx it took refuge in a crown of thorns tree[2] and settled in it. He took pity on it, turned away and left it. He said:

"She came to a crown of thorns tree of the Haumal sands and built a home in it, so is not afraid of the wolf."

The voice of the females of all animals is sharper and thinner than that of the males except for the oryx. The doe's voice is stronger and louder than the buck's and their horns are stronger.

The doe is upset by the thrust of the buck because of the hardness of his penis but takes his semen patiently.

Its meat is coarse and produces bad blood like black bile. Its stomach is the best part. Its blood congeals quicker than the blood of any other animal. Its meat is cooked with vinegar. When it has boiled, pour out and renew the vinegar with some more.

The males are called: bulls in Arabic: *thiran, arakh, qarahib, ghudub* (singular: *ghadb*).

The females are called cows in Arabic: *maha, 'in, na'aj*.

The young are called calves in Arabic: *baraghiz* (singular: *burghuz*), *ja'adhir* (singular *ju'dhur*), *bahazij* (singular *bahzaj*), *faraqid* (singular *farqad*), or *furar* (singular *farir*). At the time the calf is born it is called *tala*.

Herds are called in Arabic: *ijl, rabrab, siwar, sirb*, which is shared by others, and *khaitala*.

Their areas are low-lying land and land which is near water and grazing. They do not live in the mountains.

Hounds can catch them[3], mainly the calves and cows, helped by trained eagles.[4]

1 Ibn Hazm 438: a legendary pre-Islamic figure from whom it is said the Bani Asad tribe are descended.

2 Khayat 311 and Miller 242, *Ziziphus spina christi* or possibly the jujube tree (*Z. jujuba*).

3 Nicholson 119-121: mentions one of the best descriptions of Saluqis hunting oryx. It is to be found in the verses of the Bedouin pre-Islamic poet Labid b. Rabi'a, in which a cow has lost her calf to wolves and while she is searching for it she is discovered by hunters, who were unable to come within bowshot of her, so they set loose a pair of Saluqis on her but she injures one and kills the other.

4 For the training of falcons to hunt gazelle with Saluqis see pp. 110-113. The Arabs did not use eagles for hunting, unlike the tribes in Central Asia..

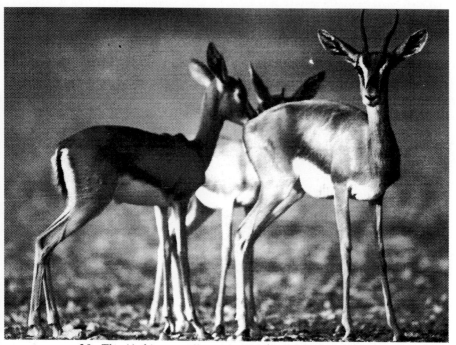

20. The Arabian gazelle on the Jiddat al-Harasis, Oman.

Gazelle (*dabi*)[1]

There are different types of gazelle according to the different areas where they live. The white ones are called *rim*,[2] they live in the sands and are the strongest.

The red ones are called *'afar*[3] and they live in the hard ground of the hills.

The *'a'sam*[4] and the wa*'al*[5] are the ones with white on their forelegs.

The Dabi is called *tala* when it is born, then *khishf*, and *shadin* when its horns appear. If it becomes mature it is a *shasr*, then a *jadha'* and finally a *thani*, as it remains until it dies.

The poet said:

"She came like the tooth of the gazelle, the like of which had not been seen, as brilliant as a lighted wick or [as desirable] as a milch camel to a hungry man."

That is to say they were becoming three-year-olds.

Ja'far b. Muhammad[6] asked al-Nu'man b. Thabit Abu Hanifah; what do you think of a person in a state of ritual purity who breaks the tooth next to the gazelle's incisor? He replied: o son of the Prophet of Allah, I do not know. He said: you claim to be a clever man yet you do not know that the gazelle does not have such a tooth as it is forever *thani* (having only two teeth at the top and at the bottom).

The way the gazelle runs

It is said (in Arabic) that when the gazelle passes *yahfu* (it runs swiftly) or *yadhru* (it raises the dust) or *yatfu* (it floats) or *naqaza* (it bounded) or *wathaba* (it sprung) when it gathered its legs together and bounded. If one lags behind the herd they say:

1 Gazelle (*Gazella*) are notoriously difficult to classify and the experts are not all agreed on some of the names. The problem here is further compounded as we do not know whether we are dealing with North African or Arabian species. Moreover the Arabs use *dabi* as a generic name which is loosely applied but often describes the Arabian or Idhmi gazelle (*G. g. arabica*, *G. g. cora*). The experts differ over its description: Gross, 27, says it is the smallest of the species; whereas Harrison 194, say it is moderately large.

2 The Rhim is classified as *Gazella leptocerus* in N. Africa (Kingdon 412) but as *G. subgutturosa* in Arabia (Harrison 202) or as *G. s. marica* (Gross 30).

3 The *'afar* or *'afri* is the name used in Arabia for the the Dorcas gazelle (*G. dorcas*) of which *G.d. saudiya* is a sub-species in Arabia (Gross 28).

4 The *'a'sam* is not recognised today but could be the Dama gazelle (*G. dama*), which has white on its underparts and legs and was once abundant in N. Africa (Kingdon 416).

5 The *wa'al* is not recognised as a gazelle but is the name given to different species of mountain goat, such as the Arabian tahr (*Hermitragus jayakari*) and even the ibex (*Capra ibex nubiana*), both of which are found in Arabia (Harrison 178-183). In E. Africa is the Walia ibex (*C. i. walia*) (Kingdon 445).

6 Probably Ja'far b. Muhammad al-Baqir b. 'Ali bin Zain al-'Abidin, called al-Sadiq, died 765.

khadhala (it has become separated) or, it springs from a high place to a low one, *tamara* (it bounded).

It retires into a covert to sleep in the heat of the summer. It sleeps twice in its covert: in the early forenoon and at dusk. They call its covert *al-naql*.

It grazes at night and sometimes in the cold between daybreak and sunrise and it keeps to the long stretches of sand and the high mountains and avoids at that time the rough ground because of the strength of its heat. The hoof on which it treads is called *zilf* (cloven*)* and its horn *ibra* (needle) which is the first part of it that appears.

They can be discovered by their tracks in the sand and soft soil and otherwise by their dung. Their cloven hoof leaves a strong imprint where it has trodden.

Hafs, the wanton jester, likened it to the vulva and said:

"When you uncover it, it is like the dainty hoof of the gazelle and the bottom of the sea deep and wide."

A Bedouin said:

"When you touch it, it is as if the footprint of the gazelle in a dry place."

A Bedouin girl said in praise of the vulva:

"My vulva is beautiful as you can see, like the footprint of the three-year-old bull in the sand."

What can be hunted anywhere is indicated by the type and location of the terrain from the hard ground, to the plain, rocky ground, dips and rises, and by the tracks and dung.

You can tell the dung of the gazelle by its smell, its lightness and its roundness.

You can tell the big gazelle by its bark.[1] If it is old, it barks. The gazelle turns white when it is old and exhausted.

It is said that it is the most pleasing of animals when it has become intoxicated with alcohol.

It only enters its covert backwards, keeping its eyes open for whatever might frighten it or its fawn.

It does not run in the mountains.

It is hunted with nets and snares[2] and by lighting a fire in front of it, which it keeps staring at and watching and so becomes dazzled and confused. If the ringing of bells is added to the fire, it becomes confused by it and can be taken.

It is hunted by she-camel as follows: it penetrates far into its grazing ground until the gazelle gets used to the sight of it, while its master hides and conceals himself. He approaches unseen, walking beside his camel so that when he draws near to the gazelle, he can catch it or shoot it with an arrow.

1 Harrison 202: the Dorcas gazelle's alarm call is "a single, short sharp bark".
2 Gazelle are creatures of the wide open spaces where it would generally be impractical to lay snares or erect nets for them: hence the use of Saluqis to run them down or the use of long-range weapons such as bows and arrows from horseback or camel

The Bedouin hunts it by running fast until he catches it by its horn.

Sometimes the gazelle is kept away from water until it suffers from thirst and ceases all movement. Sometimes a snare is laid to cut the way between it and water. Water is placed in front of the snare and it is forced to come towards it. It falls into the snare and the nets.[1] It is also hunted with hound, cheetah and eagle.

The meat of the gazelle produces blackish blood which is less harmful than cow's meat and venison. It is best cooked in water with salt. The *kushtaniya*[2] dish made from its meat is wonderful. It is called *kushat* in Persian and is the meat attached to the back. In Persian it means the meat of this part of the body.

The dried meat cut in strips from it is more harmful and more prone to upset the spleen because it is harder.

The best part of it is the liver roasted.

The fat of the gazelle provides a lot of food.

Doctors claim that the blood of the buck and of all goats is poisonous.

If it is poured hot onto the stone on which copper has been beaten, it crumbles it. If it is mixed with mercury it colours rubies. If it is mixed with dry burnt paper,[3] made into a paste with sesame oil and applied to haemorrhoids, it helps.

Its gall helps against night-blindness of the eye.

If the liver is grilled and the eyes are anointed with the gravy it is good for night-blindness as is the liver of all goats.

If the penis is anointed with the fat of the buck's testicles with a little honey during intercourse it will give great pleasure.

If you make a paste of buck's dung with vinegar and barley flour and use it as a dressing for the spleen, it will help; and if you burn it and pound into a paste with vinegar it will help against alopecia. If it is drunk with vinegar it will help against insect bites.

If its dried blood is mixed with *ladin*[4] and is rubbed on the hair, it will thicken and grow. Of all the animals it goes well with partridge.

1 The use of nets and snares here suggests therefore that this method was used in more mountainous areas where semi-permanent and permanent pools of water or seepages are found. The species *G. gazella* or mountain gazelle found in N. Africa and Arabia might therefore be indicated.
2 Kushajim 208: spells it *kushtabiya* from the Persian compound word *gusht* (meat) and *ab* (water) meaning meat soup made from venison (Ahsan 231).
3 Ibn al-Baytar 17/4 and 86/1, suggests this is paper made from papyrus. Khayat 371, says it is sesame (*Sesamum indicum*).
4 Ibn al-Baytar 3/90, a medicine made from a plant similar to ivy. The editor calls it *Cistus ladaniferus,* which is however the name given to a sub-species of rock rose.

Roe deer (*yahmur*)[1]

It is close in appearance to the gazelle and its skin is good for bow-strings.

Hare (*al-arnab*)[2]

The buck is called *khuzar*, the doe *'ikrisha* and the leveret *khirniq*. Its forelegs are shorter than the hind legs.[3]

Some of its characteristics

It has thick fur, even on the hidden parts of the jaw and under its feet.

Sometimes the doe mounts the buck when copulating and she does not become fat. The buck's penis is all bone like the fox's.

It sleeps only with its eyes open.[4] If the hunter comes towards it from the front, he can take it. There is no animal with short forelegs faster than it.

The doe menstruates and when she walks she leaves no tracks. This is done by treading on the ground with the inside of her paws to erase her tracks. Only to the skilful hound and the skilled hunter can her tracks not be hidden. Indeed she does that on the plain where her tracks show up.

She is also mounted when she is pregnant.[5]

She is not found by the sea and it is said that if she came near it she would die.

The best way to eat it is as *ziyarabaj*. Its meat is most tender. It has a property for the treatment of melancholia and epilepsy. If you anoint red spots on the face with its blood they will go away.

If pounded and roasted inside a horn, it is good for ulcers in the intestines.

If its head is burnt, it is a very good powder for baldness.

Its fur can be used as a tourniquet for a cut artery.

The Bedouin tie its paw onto boys to keep away the evil eye.

Its rennet counteracts poison. When it is drunk with the juice of beetroot and rue, if she can tolerate it, a woman will become pregnant.

Its brains prevent the growth of plucked hair.

Its dung mixed with vinegar is for impetigo.

Its gall dropped in a drink will make you sleep.

Its set is known as a *maka*.

1 Hava 901: onager but but the description suggests a small deer. Al-Damiri 2/408 says it
 has long horns and Viré, *E.I. Mahat* 1227-33, notes al-Damiri says that *al-baqr al-
 wahshi* covers the *maha* (oryx/addax), *ayyil* (*Cervidae*), *yahmur* (roe deer) and *thaytal*
 (bubale antelope). Harrison 208-9: the roe deer (*Capreolus capreolus* or *C. coxi*) was
 found in the mountains or northern Iraq into the 1950s and once extended down to the
 Mediterranean as far as Palestine.
2 Harrison 213, *Lepus capensis* is widely distributed in Africa and Arabia with many sub-
 species.
3 Xenophon 5.30.
4 Xenophon 5.11.
5 Xenophon 5.13.

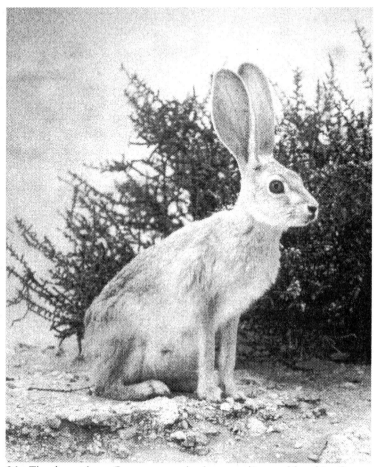

*21. The desert hare (*Lepus capensis cheesmani*) near Muqshin, Oman.*

Lion (al-'asad)[1]

22. Mounted archer.

The most prudent way of hunting it is with arrows. The horseman should shoot (and his horse should be reliable and good and have a docked tail) while facing backwards rather than to the front. Another horseman not near him should make a distraction by using his cap or one of his weapons or a ball of hair, then the other one should shoot an arrow while facing backwards. He will hurt it, weaken it and disable it. The horseman should make a knot with the reins so that the mare should not stumble and he should present the mare's rump. He should shoot facing backwards while going away. If it should turn away, go after it. If it should turn back to the horseman, let it approach to about 70 cubits, then shoot at it. If he made the attack correctly, he should shoot from the first position until he sees that it slows and tires. He should then approach to 50 cubits and draw as near as possible in order to shoot it from close to. He should not attack so long as its tail is up. If it blocks your way and you are not on your guard against it, you should take guard and make your mount appear as if it has two horns. It is said that it will run away if it looks at it. It is said that it will run away from fire.

The Byzantines mentioned that it would run away from the yelp of a puppy when it scratches its ear.

It is said that it will run away from the hunting leopard, the buck hare, the white cockerel, the oak tree and the mouse. The sap of the oak tree numbs its paws.

Its meat is the most abominable of all impure foods. It is also heavy, hard to digest and causes colic.

It is mentioned that it strengthens sexual potency and kings eat it for this reason. Learned men revile it.

It is said that its skin will keep away weevils.

1 *Panthera leo.*

People claim that if a string is made from its skin and it is added to strings made of gut or silk or something else it lowers their sounds. We mention this as it is well-known.

If some of its fat is thrown into water no animal will drink it.

The kings of Persia make the straps of their saddles from its skin.

'Amr b. Ma'di Karib[1] went into 'Umar and said: Tell me Abu Thaur what is the strangest thing you have seen? He replied: I went out one day to go to a part of Yemen. I was in a wadi called Batn Sharyan when I came upon a man who was eating a lion. He had his head inside its belly and was licking its blood. He frightened and appalled me. I shouted to the man. My shout did not make him stop. I shouted again. He paid no attention. I shouted a third time and he lifted his head. He looked at me with eyes like burning coals. He put his head back inside the lion's belly as if I was nothing. I stopped and looked at him in astonishment. He was in the way of a snake about a span long which slithered upon him. It bit him in the shoulder as he was sitting on the lion. He screamed, then fell silent and I did not see him move as he had done before. I approached him. He had a sword and a bow with him and a tethered mare. I took his weapons and he did not move. I struck him on his arms with my hand and his hand obeyed mine. I said: This is strange. I will not leave until I learn about him from someone who passes by and whom I shall question. So I turned around, when lo and behold there was a dog lying thereabouts. The lions and vultures came upon him and the dog defended him. Then night overtook me. I turned away and left him. A short time went by while and I was at the fair, when lo and behold a woman asked after the man. I recognised the description and said: I am the man who knew him and this is his sword and his mare. She said: You are right? What did he do? I said: I killed him. She said: You? I said: Yes. She said: God forbid that such as you should have killed him. You were not there. Who are you then? I said: 'Amr b. Ma'di Karib. She said: O 'Amr it does not become you to lie as you are the noblest of your people. I ask you to swear by the goddesses Allat and 'Uzza to tell the truth. So I told her the story. She said: you speak the truth. He was my brother. He was doing that because a lion attacked one of his brothers called Sakhr and ate him. He took it upon himself that whenever he met a lion he would kill it, lap up its blood and eat its liver as it had done to his brother. They called him 'Amr Dhu Kalb ('Amr of the dog) because he used to say: "the lion is only a dog". I am his sister Jandub.

It was reported to one of the Persian kings that a lion had attacked a bull of a ploughman, i e a peasant, and devoured it. He signed a letter, that is to say he wrote in order to make this matter known. If the governor of the country knew of the fact of the lion before it did what it did and if he did not go out and seek it and stop it

1 'Amr b. Ma'di Karib b. 'Abdallah, Abu Thaur, a famous horseman who witnessed the battle of Siffin (see n. 3, p. 73) when he was more than 100 years old.

attacking, the bull should be valued and the governor should be made to pay its price from the treasury. He ordered the governor to seek out the lion and kill it.

Ibn al-Munajjam[1] related to me that a drinking companion of [the Caliph] al-Mu'tasim said that 'Ali, the Prince of the Faithful[2] was angry with me as we turned away from Raqqah[3] because I rode on the water on the first journey before he rode on it himself. [4] This was because Ibn Tumar[5] pressed me to do that. When we arrived at al-'Aliyah[6] he ordered that I should return from there to Qarqisiya[7] and stay there until I had hunted a lion and sent it to him. So I turned towards there. He sent with me a number of singers and I wrote to him some other verses in a poem from which are the following:

"They charged us with hunting lions but we shall be well if the lions do not hunt us

If we should disobey because it is incumbent on those who have been charged to obey, to obey

Man can do everything he is charged with except what he can not."

When he read them he had mercy on him and wrote that he should set him free.

It is said that among the strange things about it is its neck of one bone without vertebrae. It can swallow a huge thing. Were it not for the fact that what it swallows does not turn in its throat because it is of a single bone and has little saliva, it could swallow twice that. As proof of that, it does not turn its neck and does not look round. It has few offspring because its penis hurts the womb and the lioness gives birth only slowly.

Its bite is like that of the dog. Their cure for both their bites is the same. The mark of its canine teeth on the skin is like the ring of the cupper except that inside it is more extensive and damaged as if the skin has closed over the puncture.

It drinks little water, even though it does not leave the swamps. It defecates only once a day and its dung is fissured like that of a dog's.[8] It cocks its leg to

1 'Ali b. Yahya b. Masur known as Ibn Munajjam, a drinking companion of several of the Abbasid Caliphs who died in 888.

2 The Prince of the Faithful al-Muktafi.

3 Meinecke, *E.I. Raqqah* 410-14: Raqqah was a medieval town on the left bank of the Middle Euphrates in Syria at the junction of its tributary the Balikh. In 656 the Caliph 'Ali b. Abi-Talib crossed here on his way to Siffin, the place of the battle with Muawiya b. Abi Sufyan, then governor of Damascus and later as Caliph founder of the Umayyad dynasty. Al-Raqqa was also the residence of the Abbasid Caliph Harun al-Rashid from 796 to 808.

4 This may be a reference to a ferry across the Euphrates.

5 Kushajim 174: Abu al-Abbas Ahmad b. 'Abd al-Samad b. Salih b. Tumar, a companion of the Abbasid Caliphs al-Muwaffaq, al-Mu'tamid and al-Muktafi, who died in 920.

6 A town on the western Euphrates between 'Ana and al-Rahba (modern al-Mayadin).

7 A town on the Khabur River near Rahba Malik b. Tuq which is in the triangle between the Khabur and the Euphrates.

8 Aristotle 594b21-4.

urinate like a dog. It urinates to the rear. It sits on its buttocks. It blows into the nostrils of its cub as the lioness delivers it dead like a piece of meat because she does not open her legs. It guards over it for three days.

It is said that the lion will not approach anyone who has rubbed himself with the fat of its kidneys. It does not return to its kill. The lioness produces only one cub.[1] At the tip of the lion's tail is a point. If a quiver is made of its skin it will not be attacked by insects. If its skin is put with the skins of other beasts of prey, their hair will fall out. No beast of prey will step on its tracks. If the hounds smell its urine they know where its den is. It does not attack from the front. The black is the fiercest at eating people. No other beast of prey will eat from its kill if they smell its scent.

Its advantages
It is said that its testicle, if you salt it with red borax and *Pistacia lentiscus*,[2] dry it and fry it with oil of jasmine,[3] is good for haemorrhoids, dysentery and pain in the womb.

It is said that rubbing on the fat of the kidneys protects against all beasts of prey.

Its gall with honey is good for pigs and its blood is used to rub on cancer.

If you were to consider animals and to reflect on what strength has been given them, you would see that the lion is above them.

Because of its weakness the fox escapes by running away and its tail is what helps it to dodge out of the way.

It is hunted with different devices. As for shooting it, we have already mentioned that.

The clever people hunt it with nooses. One of them stands by the wayside holding a rope made of hair from horsetails and on the other is another like him. When the two draw close they throw the nooses simultaneously which fall around its neck and then each one pulls to his side until it is dazed.

The Arabs hunt them with pits dug into elevated land, which are covered over with a puppy in the middle. The lion comes to take the puppy and falls in.

Some people hunt it in felt cloths soaked in vinegar. Its claws become caught up in them and this helps in hunting it.

1 Kingdon, 285: lions normally produce between 2 and 6 cubs. Aristotle 579a34b1: they sometimes produce only one.
2 Miller 26: the resin of this deciduous tree related to the pistachio was formerly widely used in medicine.
3 Miller 214: early Muslim sources write of an oil extracted from *Jasminum* being used for the treatment of haemorrhoids, as a purge and in various gynaecological disorders.

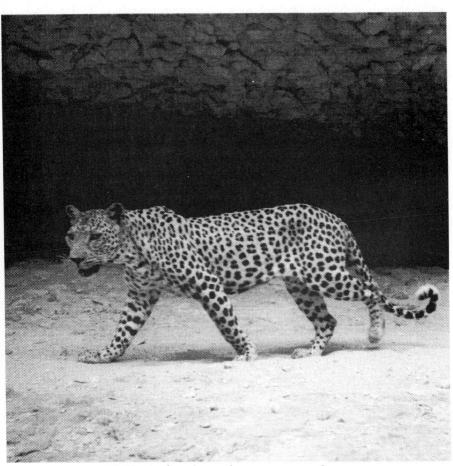

23. The Arabian leopard, now very rare, Oman.

Leopard (*al-namir*)[1]

It is said that the leopard is friendly towards all animals but an enemy of vultures. It sleeps for three days. Its breath and its voice come out like a sweet-smelling flower. All other animals will approach it and are inclined towards it because they like its skin.[2] It likes to drink wine and can be caught by it.

There are two kinds: large-bodied and short-tailed and small-bodied and long-tailed.[3] If you want to kill it, you rub on hyena fat and when you come upon it you kill it whatever way you like.

It is said that its brains mixed with oil of jasmine are good for pain in the womb.

24. Hyena/wolf hybrid, illuminating the zoology of al-Jahiz.

Hyena (*al-dabu'*)[4]

The hyena is called *ji'al* and *hadajir*. The female is called *dabu'* and the male is *dib'an* or *Umm 'Amir*. The cub is called *fur'ul*. The Bedouin claim that it is male one year and female the next.[5]

If it treads on the shadow of a dog by moonlight on the roof, it will fall down and it will eat it.[6]

1 Varisco, 246: *Panthera pardus nimr* in Arabia but Viré *E.I. Namir* 947-9 lists a number of varieties found in the Middle East..

2 Aristotle VII.9, other animals come close because they like the leopard's scent. The suggestion is here that it knows how to use its scent to attract its prey.

3 Kushajim 211-12.

4 Gross, 38: the striped hyena (*Hyaena hyaena*).

5 Aristotle *HA* 579b1729 refutes the notion that it is hermaphrodite.

6 In the Middle East it is common for guard dogs to be set loose at night on the flat roofs of houses from where they bark furiously at anything approaching.

If you come upon it in its lair and you did not block up the exits with yourself and your clothes, then moved towards it with as little light as passes through the eye of a needle, it will jump on you and cut you to pieces.

If you take a desert cucumber [1]with you it will protect you against its attack.

If you take its tongue and pass by some dogs you will not catch rabies. If the mentally disturbed eat its tail, it is good for them. Its gall is for kohl.

It is claimed that the skin around its buttocks, if burned and pounded with oil and rubbed on the buttocks of an effeminate man, the effeminacy will leave him.

If you pass by a place where there are many beasts of prey and you take with you a desert cucumber they will flee from you.

If you take its right paw, cut it off with its skin while it is still alive and put it on when going in to the Sultan, he will satisfy your needs.

If it is cooked well with oil and the chronically ill sit in its gravy, it will help pains in the joints and bad breath.

1 *Citrullus colocynthis.*

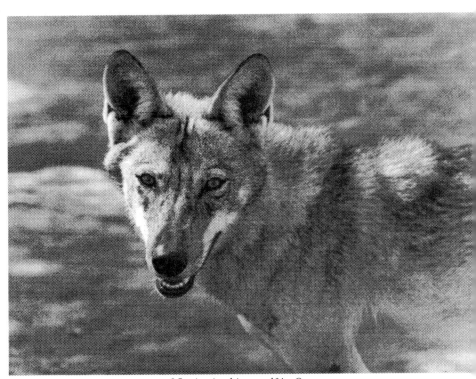

25. An Arabian wolf in Oman.

Wolf (al-dib)[1]

It is called *dib* (m.), *diba* (f.) and *duban* (pl.), as well as *al-sid, al-sirhan, awus,* and *dhuala*, its howl *al-'uwa* and *al-w''wa'a* and its walk *al-'asalan*. It is the master of the lonely place and solitude. The female is stronger and faster than the male and she is called *silqa*[2] and *al-'atrah* because of the length of her nose.

It has two offspring of different kinds: the better one is from the hyena and the other one is from the hound,[3] which is called cub.

Its teeth extend from its jaws, i.e. they are of one piece of bone, created in the jaws and do not change.

Al-fur'ul is the product of two male hyenas and a she-wolf.

It is said that if a man should come upon a male and a female wolf when they are copulating and their sexual organs have come together, he can kill them in any way he wants. Seldom are they found in such a condition because they know this. They seek out rather a wild and lonely place where man does not come.

If one wolf fights another and one makes the other bleed, it attacks the bleeding one and kills it. It is as if it becomes mad at the sight of blood as well as brave and rabid and the other one becomes submissive and weak.

It is in its character that if it meets the horseman when the ground is covered with snow, it scratches the ground with its paws and throws snow in the man's face to surprise him, then it rips at his horse to fell it and gets hold of it. If the experienced horseman sees that, he deals with it by urging his horse on and fighting and so prevents it from prevailing.

In the wolf is a nature which calls up reinforcements and is satisfied with little. If it meets man and is afraid of its weakness against him, it howls for help and the wolves hear and gather until they cover the man and devour him.

If the horse steps on the tracks of a wolf's tread, it trembles with fear and emits steam from its body.

The he-wolf mounts lying on its side on the ground. If it sees man before he sees it, it conceals its sound and its voice. If it sees him and he is anxious, it becomes emboldened and rushes at him. The predatory attack and the night raid are learnt from this.

The place in which the wolf is caught is called *al-lahma*, just as that for the gazelle is called *al-hibala* or for the lion *zubya* or for the ibex *daghul* or for the fox *dahum*.

1 There are no wolves in Africa, apart from the Simien wolf (*Canis lupus simiensis*) which is limited to parts of Ethiopia, so this description must be of the Arabian wolf (*C.l. arabs*) or the more widely spread Asian wolf (*C.l. pallipes*).
2 Al-silqa (she-wolf) comes interestingly from the same Arabic root: s-l-q as Saluqi.
3 Aristotle 607a.3.

Its excrement which falls on thorn bushes is good for colic if drunk or if the stomach is rubbed on the outside with it. What has fallen on the ground is not taken as this can kill.

Its meat is good for diphtheria.

If a woman carries its right testicle pounded in a tuft of wool, her desire for sexual intercourse is taken from her. If she urinates on its urine she will not become pregnant.

If its gall is mixed with *Memecylon tintorium* and is put on red or white spots on the face, they will go.

If its gall is mixed with honey and spread on the penis, the man will enjoy the favour of women.

Its pounded liver is good for the liver. It is drunk with a sweet sherbet if there is no fever or with cold water if there is fever.

Fox (*al-tha'lab*)[1]

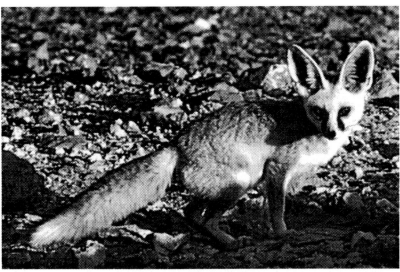

26. Ruppell's fox in Oman

The vixen is called *al-thurmula* and its cub *al-hijris*. It is known for being sly and crafty. The Arabs liken the way the horse walks to the way it walks.

1 This is probably the common red fox (*Vulpes vulpes*). Ruppell's fox (*V. ruepelli*) is also found in N. Africa and Arabia and has a grizzled coat (Kingdon 222). The fennec (*V. zerda*) is also found widely there.

PREY 81

Its weapon is its runny excrement, which is more fetid than that that of the bustard.[1]

Its penis is in the shape of a tube, one half is bone which looks like a drill and the other is sinew and flesh.

If you bring some wild onion[2] and throw it on its den, the wolf will run from it. If its fat is mixed with oil and rubbed on, it is good for gout.

Its fine fur is valuable, the black being the most valuable.[3] Some resemble the fennec[4] and some are striped. The worst is from the desert.

It wallows in the dust on agricultural land and nothing grows in that place.

If it should mate with a female dog, she will produce a dog in the likeness of the Saluqi which is like none other.[5]

Its flesh is bad and stinking.

Its gall with gum ammoniac[6] and celery[7] juice is good for elephantiasis if injected via the nose as soon as it starts and then every ten days.

It is boiled alive in oil and whoever has pain in the joints will benefit from it.

Its sleeping place is a hole or a stretch of sand.

Bear (al-dubb)[8]

In the plural it is called al-dibaba. It lives in the bare and waterless desert and the mountains.

The female carries its young for days to avoid the ants, while waiting for their limbs to open out[9] and continues carrying them until their limbs open out.

It puts its young under a walnut tree and climbs up, breaks the nuts and throws the kernels until they are full when it comes down.

The big ones take a piece of wood, carry it towards the horseman and smash him.

It does not appear in winter but only in summer.

If it is hungry it sucks its paws, it feeds on this and is satisfied.

Its gall with honey and pepper will grow hair on a bald head.

1 Allen 143: the MacQueen's bustard (*Chlamydotis undulata Macqeenii*) has the reputation of squirting its mutes at an attacking hawk to blind it or gum up its feathers.
2 Ibn al-Baytar 128/3: *Seilla maritima.* but as noted above it could also be the wild iris.
3 Kingdon 222: Ruppell's fox (*Vulpes rueppelli*) is also found in N. Africa and Arabia and has a grizzled coat.
4 Kingdon 224: the fennec fox (*Vulpes zerda*) is widely found in the desert areas
5 Aristotle 607a3 says this combination produces the Laconian hound, a term which the Arabs translate as Saluqi. However Al-Qazwini 29 says that the hound of Saluq is a cross between a dog and a wolf!
6 Ibn al-Baytar 34/1 & Khayat 27: *Ferula,* a genus of umbelliferous plants yielding gum-resin, typified by the giant fennel.
7 *Apium graveolens.*
8 Harrison 124-125: *Ursus arctos syriacus* was once found in Arabia.
9 Aristotle 579a24 says that the bear cub's limbs are "practically unarticulated".

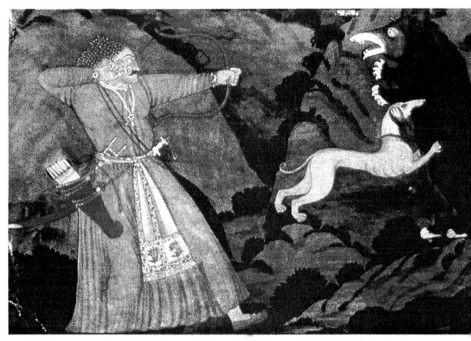

27. A Saluqi attacking a bear, from a Mughal miniature.

If its eye is hung on a man no beast of prey will approach him and he can pass by people without their knowing it.

If some of its blood is drunk by a madman, it will do him good. If some of its fat is poured on the base of the wing feathers, they will grow.

If its gall is pounded with pepper and put on fox mange the fur will grow.

If you apply its blood like kohl to the eye the hair will grow after it has fallen out.

If its fat is pounded with pomegranate and made into a paste with oil and applied to the eyebrows the hair will grow thicker.

If it is packed into a fistula it will get better.

Wild Boar (*al-khanzir*)[1]

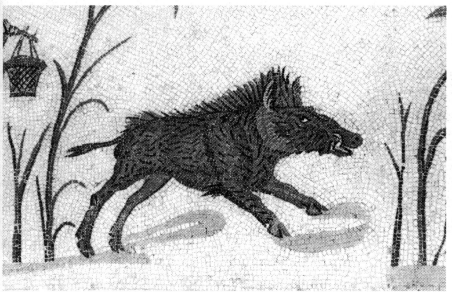

28. A wild boar, detail of a Roman mosaic from Chebba, Tunisia, 3rd century AD.

The wild boar produces many offspring and the number of its piglets may reach twelve. It mates frequently, while the sow is grazing the boar is on top of her. The proverb says: Do not be like the wild boar. Intercourse is its main concern.

Its flesh is most suitable for man.[1] It is one of those animals that puts on weight quickly. It does not discard its teeth and as a result the point of its teeth

1 Harrison 209-212: the wild boar (*Sus scrofa*) has a wide range across N. Africa, Iraq and Syria, wherever there are dense thickets and reeds.

becomes sharper and its hold is made stronger, because the original construction is stronger than that which nature changes.

It is wary of traps as water buffalo are wary of night raids.

Once it uses its tusks nothing can oppose it. Therefore it is more prudent for anyone threatened by it to lie face on the earth and conceal his face, if he rather than anyone else is the object of the attack.

It is one of the foolish land animals which cannot be tamed. If the falcon is constipated, feed it some of its fat with a little ginger and mix into its food.

Civet (*al-sinnawr al-barri*)[2]

It is abominated and cursed on a par with the wild boar. It is better to leave it alone than to hunt it. Shooting it with arrows is the most efficient way. During the waning of the moon its sight is sharper than during the waxing.

Among them is a kind that will leap at the face of man.

Spiny-tailed Lizard (*al-dabb*)[3]

It is wingless but lays eggs. When it emerges from the egg it is called *hisl*, next *ghaidaq*, then *mutbakh* before it becomes *dabb*. The female is called *dabba*. If she has a number of eggs in her belly, she is *makn* (with eggs). The name of the eggs is *makn*. It lays seventy eggs in which are seventy *hisl*. It lives in a hole or burrow called *al-nafiqa* or *al-qasi'a* or *dama* or *al-rahita*. If it is sought in one hole it escapes from the mouth of another.

From the word *al-nafiqa* comes *al-munafiq* (dissembler)

The Arabs hunt it from the appearance of the Pleiades[4] to the appearance of the three stars of Gemini. It is hunted by putting the hand down the hole and moving it about until it comes out, or by holding its tail or by devices.

The proverb says: The matter is too big to be caught by the hand.

It is dug out and taken but after this period it is exempt as it is emaciated. If it loses one eye it does not go far. It keeps to its feeding ground.

If it does not seek a mate it grows fat.

The Bedouin say: what would you enjoy eating? The reply: a spiny-tailed lizard that is one-eyed and cannot mate.

Nothing is known to live longer after it has been slaughtered.

If it calls, they say in Arabic: *fahha* or *yafihhu*.

1 This is a curious admission. Pig meat is not lawful for Muslims.
2 Kingdon 267: the African civet (*Civetticus civetta*) is a sub-Saharan creature and it is possible that what is meant here is the related *Viverrid* the common genet (*Genetta genetta*) which is found in the Maghrib and in parts of Arabia (as *G. felina grantii* – Harrison 150-1).
3 *Uromastyx microlepis.*
4 A cluster of small stars in the constellation Taurus. Varisco 96: in ancient Greece the rising and the setting of the Pleiades divided the year in half.

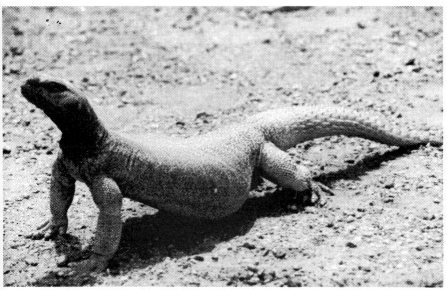

29. A spiny tailed lizard in Oman

They say that it has two penises with which it can mate and which are called *al-nizk* (the spear). They say that it keeps a scorpion under its tail so that if the hunter sticks his hand in the hole to take it, it stings him.

It is hunted with monitor lizards, just as snakes are hunted with hedgehogs.[1]

The Arabs ban killing monitors and hedgehogs because they eat vipers.[2]

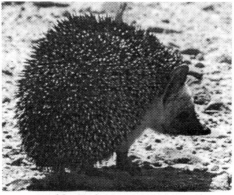

30. Hedgehog in Oman.

1 Harrison 5-9: the Ethiopian hedgehog (*Paraechinus aethiopicus)* is probably intended here as it is widely found across N. Africa and Arabia.

2 Scott 57: possibly the widely distributed sand viper (*Cerastes cerastes gasperetti*).

Ostrich (al-na'am)[1]

31. A Saluqi attacking ostriches, detail of a Roman mosaic from the amphitheatre at El Kef, Tunisia.

In Arabic *al-na'am* is the collective word for ostrich and is masculine, like *al-hamam* for pigeon. The singular is *al-na'ama* and *al-hamama* respectively for both the male and the female. They say: three *na'amat* or *na'a'im* and three *hamamat* or *hamaim* up to ten. If there are more they are *al-hamam* and *al-na'am*.

The male is called *al-zalim*, plural *zulman*, or *al-hiql* and the female *al-hiqla*; or *niqniq* and *niqniqa*. *al-hijaff* is very large and heavy with full feathers. The male, *al-khudaidid*,.is so called because of its light weight and the long one is *al-hajanna*. *Al-azj* takes long strides. *Al-arbad* is black. *Al-sa'l* has a small head, which they also call *si'wan* and *si'wana* because of its light head. *Al-'asak* has no ears. *Al-maslum* is similar. Every animal that shows no ears lays eggs, while every one that shows its ears gives birth. *Al-asham* is the black one.

Al-khadhib is the name given in the spring, because the pasturage colours its shanks and reddens its beak and legs. *Al-ahass* is the one that has lost its feathers through old age. Its chick is called *al-ril* for the male and *al-rila* for the female. The young are called *al-haffan*. They say also *al-ifal*, or *afil* in the singular or *afila* and they say it is first a *haffan*, next a *qalus* and then a *ril*.

Al-naqnaqa is the call of the female when it lays eggs or of the male generally. *Al-'irar* is the cry of the male. They say: the verb to cry like an ostrich is *'arra, ya'irru, 'iraran*. The cry of the female is *al-zimmar* and it is lower than that of the male. From this comes: if the man is restless at night [Arabic *ta'arra*], let him mentions the name of Allah.

They say: *al-'irar* for the male when it seeks the female and *al-zimmar* and *al-inqadh* for the female when it seeks a male.

They call the urine of the male: *al-zajal* and its droppings: *al-sawm*.

1 Hollom 13: *Struthio camelus* became extinct in Arabia in the 1930s.

They say: *nasaha* when the ostrich mounts and *qa'a* when it holds back.

The nest is called *al-udhi* or *al-ufhus* or *al-qurmus* or *al-mabaidh* (sing. *mabidh*).

They use the verb *qadaha, tadhi dahi* or *tadhu dahwa* or *duhi* to describe the ostrich laying its eggs in the sand.

They say for bad eggs: *mariq*.

They call the outer shell *al-qaid* and the thin skin underneath *al-ghirqi*.

When the chick has left the egg, it is *tarika* (empty) or *taraik* (pl.). The female *anfaddat* (scattered) when it lays its eggs. The ostrich's plumage is *ziff*. They say of it that it is *al-khamil* because it resembles *khamal* (velvet).

They say *al-qartaf* or *al-haramil* for the quill of the feather on which there is nothing.

They also say for a flock of ostriches *ra'ala, khit, qit'an*, and *khitan*. They say: I saw a *khit* (flock) of ostriches grazing and eating.

They call the mouth of the ostrich: *al-minqar* and the chest: *al-laban, al-juju* and *al-kalkal*; the base of the tail *al-zimakka*; and the front nails of the forepart of the feet *manasim*, just as *khuff* is for the camel. It has a very hot stomach which will cook anything. It is called *dhat zahm* when it becomes plump. *zahm* (fat) is used for both the ostrich and the hoofed animals which live in the sand.

The proverb says: What brings together the female ibex and the ostrich, when the ibex lives in the mountains?

It is said: He has a better sense of smell than the ostrich.

It is said that it does not hear but others also say that it is does hear.

If fire is lit near her, she will leave her eggs and run away from it. Sometimes she leaves her eggs and incubates those of another.

Its meat is very moist and slow to be digested. If its gizzard is dried and eaten dry, it stops defecation.

Its meat in *harisa* (pounded meat and wheat) is good, except that it gives indigestion.

It is said that it runs fastest into the wind. The stronger it blows the faster it runs. If you know this, you approach it with the wind. It is the fastest thing at fleeing.

It is hunted with black cloths which are hung up where it feeds. When it becomes at ease with them, the hunter puts one on and catches it.[1]

It is said that the penalty for a pilgrim who kills it is a female camel, because it resembles a camel, so the retribution must be the same. Whoever damages its eggs has to pay the price, according to the jurists by analogy.

1 Viré *E.I .Na'am* 828-831: it was also hunted with fast mounts and Saluqis, as well as sakers. It required five specially trained sakers: one seized the head, two the neck and the other two the thighs.

Its stupidity is that when the hunter overtakes it, it sticks its head in the sand and makes out that it is hidden.

The coloured ostrich with plenty of feathers can only be overtaken by the hunter with difficulty, except when it is summer and it sheds its feathers and grows fat.

Eagle (*al-nisr*)[1]

It is called *nisr* and *ansur* and when it is old *qash'am*. Its beak is called *mansir* with which it can tear flesh. Its talons are like beaks.

Al-madhrahi is of a pronounced red colour.[2] There are also jet black ones[3] and *al-arbad* [4]is the colour of ashes, as is *al-akdar*. It is said: the eagle is *khaffaq* and is long-lived.

It is said: time has forgotten Lubad.[5]

Al-falatan is an eagle which hunts monkeys.[6] It is neither a bird of prey nor a hunting bird but eats carrion, with which it can be caught as it has a keen sense of smell. When it smells something fragrant, it dies immediately. It brings a stone from India to facilitate birth.[7]

If the female is afraid for her eggs from bats, she lays out under them leaves of the plane tree.[8]

1 Heinzel 78: *Aquila.*
2 Hollom 65: possibly the golden eagle (*Aquila chrysaetos*) whose range covers N Africa and Arabia. It is a tawny brown colour.
3 Hollom 66: this could refer to Verreaux's eagle *(Aquila verreauxi)* which is coal-black with white marking on rump and wings, though today it is only a rare vagrant to the region. Heinzel 80: it might also refer to either the spotted eagle (*Aquila clanga*) which in its adult form is either dark brown or blackish or the tawny or steppe eagle (*Aquila rapax*) which can also be very dark brown.
4 Hollom 65-6: this could refer to the pale brown almost white version of the tawny eagle or either to Bonnelli's eagle (*Hieraaetus fasciatus*) or the booted eagle (*Hieraaetus pennatus*), both the latter two were used for hunting - Viré *E.I. Bayzara* 1152-55.
5 Lubad was one of the seven eagles of Luqman, a wise man.
6 No such bird in the region matches this description.
7 Varisco 143: Aelian 21 notes curiously that cranes carried stones as ballast for their journey from Greece to Egypt.
8 Mitchell 272: the oriental plane tree (*Platanus orientalis*).

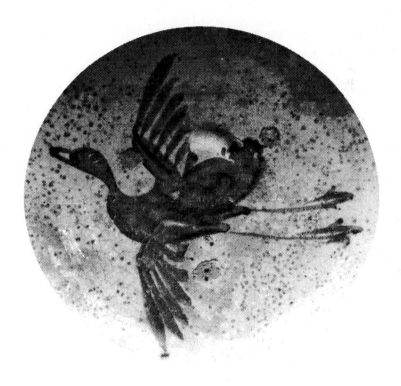

32. A crane on a fritware dish from Iran, 15ᵗʰ century AD, in the British Museum.

Crane (*al-kurki*)[1]

The call of the crane can be heard for miles. They keep watch. They do not settle in a place without putting one on guard to give warning. They have a leader which they obey and follow.

They say that its meat is very tough and it cannot be eaten unless it is boiled, had the blood drained from its veins and is cooked as *sikbaj*.[2]

They say that it supports its parent and this is known only in the crane and the ibex.

If its arrival is early in the season it indicates the severity of the winter

Crane (*al-ghurnaiq*)[3]

Al-ghurnaiq is also a *kurki*, except that it is black-coloured and long-billed. The plural is *al-gharaniq*. When it is young its feathers are grey but when it becomes an adult they are black. This is not so with others. The female is mated when standing up.

Crane (*al-rahwu*)

This is a bird like the common crane. All waterfowl are called '*ibn al-ma*' (son of the water).

Stork (*al-laqlaq*)[4]

Its name come from its call, which is a noble sound. It eats snakes.

1 Heinzel 110: *Grus grus* is a heron-like bird distinguished by its red crown and white stripes from cheek down the neck. Varisco 142: it was a favourite game bird and its meat was considered a powerful aphrodisiac.
2 Ahsan 83: *sikbaj* was a broth made with fat meat, carrots or egg-plant, almonds, currants, dried figs, date-juice and vinegar and spices such as coriander and cinnamon.
3 Heinzel 110: probably the demoiselle crane (*Anthropoides virgo*) which has a black lower neck and breast in the adult for, where the juvenile is grey.
4 Hollom 36: this would be the white stork (*Ciconia ciconia*) mainly a summer visitor to its breeding areas in N. Africa, but winters in S. Iraq.

Bustard (*al-hubara*)[1]

They call both the male and the female *hubara*. The male is also called *al-hubruj*.[2]
The meat of the *hubruj* is coarse. The plural is *hubariyat* and it is a land fowl.
It eats everything that crawls, even black beetles and people detest therefore to eat
it.[3]

They call its chick *al-nahar* and *al-qalus*.

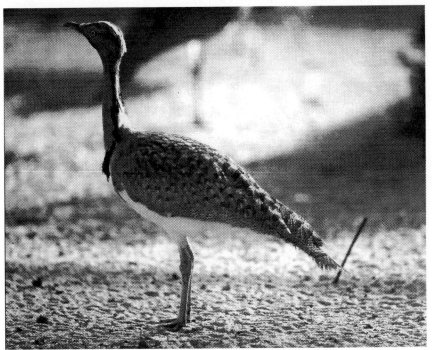

33. Hubara bustard in Oman.

1 Allen 129: the Macqueen's bustard (*Chlamydotis undulata Macqueenii*) is the
traditional quarry of the Arabs in the Arabian peninsula. Hollom 83: the little bustard
(*Tetrax tetrax*) is resident in N. Africa, and it winters in parts of the Middle East. The
Arabian bustard (*Ardeotis arabs*) a huge bird standing up to 1 m. tall is occasionally
found in Morocco and Yemen. The great bustard (*Otis tarda*) is occasionally seen as a
vagrant in N. Africa and N. Syria and N. Iraq. Although the bustard is a strong flier
with powerful slow beats of its long wings, it frequently seeks to escape from hawks by
running on the ground where there are bushes and other obstacles. For this reason the
Arabs sometimes fly their hawks in tandem with Saluqis, which force the bustard into
flying again.
2 Viré, 1967, 278: *al-hubruj* is the great bustard (*Otis tarda*).
3 A curious remark, as the bustard is generally regarded as good eating.

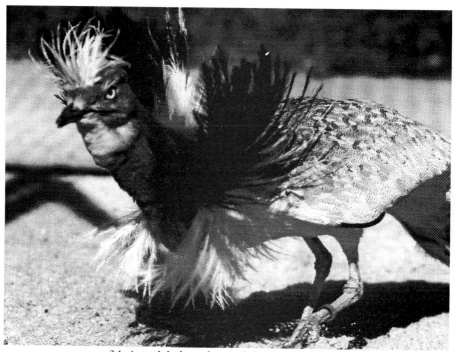

34. A cock hubara bustard displaying, Oman.

Curlew (al-karawan)[1]

This is a bird. The plural is *kirwan* and the diminutive *kurayyan* or *kuraywan*.

The Arabs claim that the partridge is the chick of the curlew and it is one of the stupid birds.

They say to it: O *Kara*! Be still! So it cleaves to the ground until it is shot. *Kara* is the abbreviation of *karawan*. Its breast is broad.

Partridge (al-ya'qub)[2]

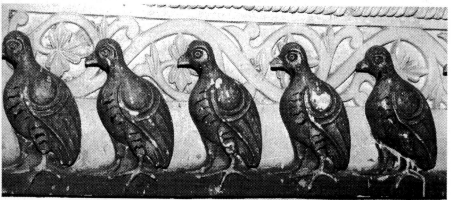

35. Frieze of partridges, Umayyad period, Amman, Jordan.

This is the male of the partridge (*al-hajal*).[3] The female is *al-ghubra'* and the chick is *al-sulak*.

They also call it *hajal* and *hajla*.

The Najdi type is black with red legs[4] and the Tihami has some white and black in it.[5]

If the female is approached while she has chicks, she will drop down and pretend to be lame so that you will turn towards her, thus saving the chicks. Then

1 Allen 129: this is probably the stone curlew (*Burhinus oedicnemus saharae*), which inhabits N. Africa and the Middle East, rather than the common curlew (*Numenius arquata*), which occurs on most coasts of the region.

2 There are various species from the *Alectoris* and *Perdix* families.

3 Viré, 1967, 266 & 268: *hajal* is the Barbary partridge (*Alectoris barbara*).

4 Hollom 74: possibly Philby's rock partridge *(Alectoris philbyi)* which is distinguished by its large black throat patch. It has pinkish red legs but is found in S.W. Arabia rather than the Najd, where the sand partridge (*Ammoperdix heyi*) is found but it has black only in bands on its flanks.

5 Hollom 75: on the Tihama the Arabian red-legged partridge (*Alectoris melanocephala*) occurs. It has white and black on its head and throat.

she flies off and saves herself. The female stands in front of the male and when the wind blows she is fertilised by him.

Crow (al-ghurban)[1]

They call the plump black one al-ghudaf[2] and the rotund one al-hadhaf. There is the spotted one[3] and the one with dusky yellow coloured feathers.[4] The goshawk[5] is preferred for hunting the crow, because of its wiliness. It is called al-'araj (lame) because it hops as if it is shackled.

Among its names are: hatim. From wishful thinking, they call it al-'awar (one-eyed). They also call it 'ibn da'ya for the way it lands on the buttocks of the camel, which are its hindquarters. The verbs to describe its call are: na'aba, na'aqa and shahaja.

There is a saying: a country where the crow does not fly away, i e it finds everything it wants there.

It is a bird that migrates.[6] There are some that can repeat everything that they hear, like a parrot.[7] They are mainly seen in autumn in the date palms and in winter among the houses. The black ones are mainly on Mount Tikrit[8].

It is said that they mate with their beaks locked together and that they do not alight on the fruit of the date-palm when it abundant for if they do they are afflicted with a well-known disease, as if the fruit is forbidden to them and it is protected from them.

Despite its caution it rarely escapes the gun because its excessive caution drives it out of its mind. It is strong in collective defence if it sees an enemy and often bands together against a bird of prey and attacks it.

1 Hollom 228: possibly the fan-tailed raven (Corvus rhipidurus) which occurs in Arabia and is stout and all-black.

2 However Houlihan 166 says that al-ghudaf is the name given to the rook (Corvus frugilegus) which visits S. Iraq and Syria in winter but is rare in Egypt and vagrant in Algeria.

3 There are no spotted crows but the pied crow (Corvus albus) has has a distinctive broad white collar round its neck and across its breast (Hollom 228).

4 Hollom 229: Tristram's grackle (Onychognathus tristramii) has prominent rusty-orange primaries in flight.

5 Hollom 55: the goshawk (Accipiter gentilis or Allen – Astur gentilis gentilis), which is a kind of large sparrowhawk, is a vagrant in N. Africa and Arabia and to this day is not normally used there for hunting. Allen 116-7, notes however that it was favoured by the Persians.

6 Crows are not migratory but starlings (Sturnus vulgaris) do and are found as vagrants in parts of the region.

7 Austin 271: possibly a reference to the Asiatic mynahs of the genus Gracula which were kept as talking cage birds but they are not found naturally in the region, though some escapees might survive.

8 Tikrit is a town in Iraq roughly halfway between Baghdad and Mosul.

Magpie (al-'aq'aq)[1]

The way it walks is used as a simile.

Egyptian Vulture (al-rakham)

The female is called al-'anuq.[2]

Among the sayings about it is: stronger than the eggs of al-'anuq.

It eats carrion and does not hunt.

It is called 'umm ji'ran and 'umm Qais, the male al-'udmul and the chick al-naqaniq. It rests at night only in the highest place it can reach.

It is the first of the birds to start migrating and in this way it is an indicator for the hunters. It also the first to return whence it originally came.[3]

Kite (al-hidaa)[4]

It is well-known and the plural is al-hida'u.

Lark (al-mukka')[5]

A small fine white bird with a long neck, long white shanks, small beak and short tail and it is present at all times. It has a beautiful song as it ascends into the sky and descends. The female is a mukka'a.

Francolin (al-durraj)[6]

The male is called al-haiqutan and is one of the best birds for its meat. It is best caught in the bushes because it feels safe there and goes to sleep. Few are found in the mountains. It has a crop and a mouth to its stomach, which is rare in other birds.

It is caught in many ways: you can even imitate its song and it will listen to it. You can then approach it and catch it.

It is wonderful eaten as masus.[7]

1 Al-Jahiz 174/2 says it is a black and white bird like a crow and Ibn Sida 152/8 says it is known for stealing.

2 Houlihan 148 says Anuuq is the name for the Egyptian vulture (*Neophron percnopterus*).

3 Vultures are not migratory birds.

4 Viré, 1967, 266: black kite (*Milvus migrans aegyptius*). Houlihan 147: the black-shouldered kite (*Elanus caeruleus*).

5 Al-Jahiz 23/7 says it is a bird like a lark but the description does not fit any of the known species. However Dr S.A. Mohammed confirms it is the skylark.

6 Allen 134: al-durraj is the name used in the Arabian peninsula for the cream-coloured courser (*Cursorius cursor*). However the description here does not fit it and it is more likely that it is used here as in Iraq and Syria for the francolin (*Francolinus francolinus*), which is also the translation preferred by Viré 1967, 286, Hava and Wehr dictionaries and Dr S.A. Mohammed. cf. p.93.

7 *Masus* is a process of softening the meat by maceration.

A feature of its eagerness to mate is to seek the places where the eggs are and spoil them so that the hen is not occupied with something else.

It seeks every branch that bends to make into a nest, as does every bird·with a crest.

Pigeon (*al-hamam*)[1]

Al-hamam is the collective and the singular is *hamama* for both the cock and the hen.

The Bedouin do not know the town pigeon and if they should see one they would call it *al-khudhr*. The pigeon for them is really *al-qata* or *al-qamari*.[2]

Pigeon (*al-sammam*)

This is a bird like *al-hamam*.

Dove (*al-yamam*)[3]

36. The Basmallah in the form of a bird.

This is a wild pigeon and all the pigeons of Makka are *yamam*. The difference between *al-hamam* and *al-yamam* is that the base of the tail of *al-yamam* where it joins the back is whitish. It is like the town pigeon. The base of the tail of the hen pigeon has no white in it.

They call the wild pigeon *hamam Turani*, the origin of which is from the verb *tara'a*, meaning that it comes from somewhere you do not know.

1 *Al-hamam* is the generic name for pigeon (*Columbidae*) and probably indicates here the stock pigeon (*Columba oenas*) - Houlihan 159. Viré. *E.I. Hamam*: 108-9, in the 8th-13th centuries pigeon flying enjoyed great popularity among Muslims and pigeons fetched high prices. They were also used for pigeon post.

2 Viré, *E.I.*: medieval Muslim naturalists incorporated pigeons with sangrouse, which are morphologically alike. So this may explain why the Bedouin confused the pigeon with the sandgrouse (*al-qata* - Houlihan 158) or the turtle dove (*al-qamari*-Houlihan 159).

3 Houlihan 159 lists *yamam* as one of the generic names for pigeons and doves. However Dr S.A. Mohammed says that this is the rock dove (*Columba livia*). Viré, *E.I.*: it is the stock-dove (*Columba oenas*) or the blue dove.

When it coos they say the pigeon *hadhada* or *hadala* or *saja'a* or *qarqara* or *nabaha* when it is frightened away.

Some goshawks will stoop on a hen pigeon while it is sitting and some while it is flying. Some will ignore them. The different kinds of goshawks are not unknown to the pigeons and how they hunt. So they do the opposite. Like cranes they associate with their own kind. They mate with their stomachs touching the ground.

It is forbidden to take their squabs in the eggs, for it is said by the Prophet, may peace be upon him: Leave the bird in its egg! The meaning is - do not hunt it until it lifts itself off. It is said that this was meant to forbid the use of birds as omens.

They call the pigeon's squab *al-jawzal* and *al-nahidh*. The best of them are the spring and autumn ones and the worst the summer and winter ones. It is very hot.

Sandgrouse (*al-qata*)[1]

There are two varieties: *al-kudri* and *al-juni*.[2] They are called *qatah, qatawat* and *qutayyat*. *Al-kudri* is dust coloured and is speckled with white and black on the back and breast and yellow on the neck. It has a short tail. They call it *al-'arabiyyah*. The ash-coloured are sweeter than the black-winged, whose breast is white. The black-winged is called *'atma* because it does not display when it calls.

It is hunted with the falcon and it can soar strongly.

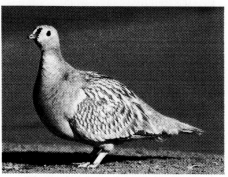

37. Crowned sandgrouse in Oman.

Sandgrouse (*al-ghatata*)

This is similar to the *Qata*, except that it is dust-coloured and has a short neck and tail. The *qata* is more common among the Arabs.[3]

1 Heinzel 166-8: *Pteroclidae*. Varisco 143: the Romans considered the brains of the sandgrouse an aphrodisiac that led women to grant sexual favours.

2 Varisco 143: *al-kudri* is the crowned sandgrouse (*Pterocles coronatus*) and *al-juni* is the chestnut-bellied sandgrouse (*P. exustus*).

3 Kushajim 278: says it is the most numerous bird in the desert.

The saying goes: cleverer than the *qata* at finding its way, because it lays its eggs in the waterless desert and brings water for its young from far off by day and by night. It brings in its crop on the darkest night food for its young. When it approaches its young it calls: *qata, qata,* then it swoops down and never makes a mistake without any sign or tree or indication.

Its meat is useless from the spleen.

Ring Turtle Dove (*al-warshan*) [1]

It is very similar to the pigeon (*al-hamam*), except that it has a larger body and breast and lives longer. It has a homing instinct. If its young are in a palm tree which has spines, it moves to them. The hen is very tender towards her squabs.

Great Grey Shrike (*al-surad*) [2]

The plural is *sirdan*. It is spotted with a large head and lives in trees. It is called *mujawwaf* because of its white breast and green back.

It is called *al-sumait* and *al-akhtab al-akhyal*.

The spots are of two kinds: white and black. It has a large beak and talons. It is about the size of *al-qariyya*.[3] It can only be seen at the top of a mountain or a tree and it cannot be caught.

It catches sparrows and small birds. The Arabs believe it brings bad luck.

It is said that a snake went towards a shrike with its mouth open but the latter rushed at it with a thorn in its throat and killed it.

Shrike (*al-nuhas*) [4]

This is a bird that resembles the shrike but does not run fast. It constantly flicks its tail. It catches sparrows. The plural is *nihsan*.

Rail or Crake (*al-mur'a*) [5]

This is a bird the plural of which is *mura'*.[6] It has long legs. It descends with the rain as if it comes from the heavens.

1 Viré. *E.I. Hamam:* 108-9, ring dove or wood pigeon (*Columba palumbus*); but Dr S A Mohammed lists it as the palm dove (*Streptopelia senegalensis*).
2 Dr S.A. Mohammed: great grey shrike (*Lanius excubitor*). Jayakar's translation of al-Damiri, vol. 1 38: shrike (*Lanius fallax*). Houlihan 165: *surad* is a generic name for shrikes (*Lanidae*), of which there are several subspecies in the region, though none matches the description here.
3 Al-Damiri 2/335: a short-legged bird with a long beak, green-backed. Dr S.A. Mohammed: more likely the green woodpecker (*Picus viridis*).
4 Houlihan 165: *nuhas* is another generic name for shrikes.
5 Houlihan 153: *mura'ah* is the generic name for rail and crakes.
6 Al-Damiri 2/455: it looks like a francolin and makes good eating.

Collared Turtle-dove (*al-fakhita*)[1]

It is the collared dove. Both the cock and the hen are called *fakhita* and the plural is *fawakhit*.

Turtle-dove (*al-qumri*)[2]

It is like *al-fakhita* and laughs like a human being.

Turtle-dove (*wisaq hurr*)

Like *al-qumri*,[3] it is named after its call. It has no plural or feminine.

Palm-dove (*al-dubsi*)

The hen is *dubsiyya* and the plural is *al-dubasi*[4].

Namaqa Dove (*al-hummahim*) [5]

It is a long-tailed pigeon, smaller than *al-dubsi*. It is a wild pigeon.

Redstart (*al-hummara*)

It is a kind of sparrow.[6]

Owl (*al-dawa'a*)[7]

38. Owls on a lustre tile from Kashan, Iran, c. 1260 AD.

1 Hollom 123: *Streptopelia decaocto* is resident across the region.
2 Viré. *E.I. Hamam*: 108-9. *Stretopelia turtur.*
3 Kushajim 280: this is the cock *qumri* and is collared.
4 Viré. *E.I. Hamam*: 108-9. *Streptopelia senegalensis.*
5 Viré. *E.I. Hamam*: 108-9, spells it *humhum* = long-tailed or Namaqa dove *(Oena capensis)*. Confirmed by Dr S.A. Mohammed.
6 Houlihan 171: *Abu humra* and *humayra'* are names given to the redstart.
7 Al-Jahiz 2/298: a night bird. Al-Damiri 2/123: a type of owl. Heinzel 179: possibly Bruce's scops owl (*Otus brucei*) or the little owl (*Athene noctus*) both of which have this colouring.

A small yellowish bird, speckled on its back and yellowish on its underside with some ash colour. It has a short neck and a short tail. It is named after its call.

Firecrest (al-dujra)

A small sparrow.[1]

Coot (al-ghuwaira)[2]

A similar bird but black. It builds its nest with stones.

Chestnut-bellied sandgrouse (al-hawiyya)[3]

It is very small.

Tristram's grackle (al-sudaniyyat)[4]

It is blackish with a long tail. A small bird, it lives in the trees.

Al-fattaha

It is a red bird.[5]

Al-shaquqa[6]

Small.

Al-shuqaiqa[7]

One of the smallest birds.

1 Kushajim 281: has al-sa'wa, which Hava translates as a small sparrow or bullfinch (Pyrrhula pyrrhula), which is only a rare visitor to N. Africa. Al-Baladi 191, n.3: suggests a bird of the Regulus family and the firecrest (Regulus ignicapillus) is most likely.
2 Kushajim 281: has al-ghurayr, which is the diminutive of al-ghurr, described in Jayakar's translation of al-Damiri as coot (Fulica atra), though it is not at all like the preceding bird.
3 Kushajim 271: has al-juna (see entry for sandgrouse above).
4 Lisan al-'Arab: it is a bird that feeds off grapes and locusts and lives among the rocks in the Sinai Peninsula. Jayakar, al-Damiri 2/91: starling (Sturnus vulgaris). However the latter has a short tail and Tristram's grackle (Onychognathus tristramii) is more likely: it is found in Sinai.
5 Possibly the redstart (Phoenicurus phoenicurus). Dr S.A. Mohammed points out that fattah are the wagtails (Motacilla), none of which is however red.
6 Dr S.A. Mohammed suggests that this is of the warbler family (Sylvidae).
7 See n. 6 above.

Al-nahqa

It has long legs and a long neck and beak. Dust-coloured.

Weaver Bird (al-tunawwit)[1]

Blackish.

Al-tahiyya

A bird similar to al-qumri.

Al-yahmum

A bird which resembles al-dubsi or is smaller than that.[2] Black on the underside as far as its tail with a black head, neck and breast and yellow beak and legs. In the plural yahamim.

Al-su'su'

A speckled bird and restless. It catches grasshoppers.

Al-wahdaq

It looks like al-qunbura.[3]

Al-balansi

A bird with a long tail, a short beak and legs. It calls a lot with a harsh cry. The plural is al-balsus.

Brambling (al-shirshir)[4]

It is of the colour of gunpowder.

Abu Sabra

It has a black head and wings.[5] The plural is sabrat.

1 Hollom 237: Ruppel's weaver (*Ploeceus galbula*) has a deep chestnut face which looks blackish from a distance and is found in South Arabia.
2 Viré. E.I. Hamam: 108-9, it is the same as *al-humhum* = long-tailed or Namaqa dove (*Oena capensis*). However al-Damiri 2/573 believed it to be a type of partridge.
3 Kushajim 275: writes it *al-rahdan*, which Hava describes as a lark of Mecca and *al-qunbura* is a lark. However *Lisan al-'Arab* says that it is a red-breasted bird with black head, wings and tail and the rest red, though that is unlike any lark.
4 Houlihan 174 gives a slight variation, *al-shurshur* (*Fringilla montifringilla*).
5 *Lisan al-Arab* describes it as a water bird in Iraq. Possibly a moorhen (*Gallinula chloropus*).

Ru'aim[1]

Its neck is red and the rest is dust-coloured.

Al-musa'a

A bird which flashes its tail. Green.

Common Quail (*al-salwa*)

Reddish.[2]

39. Quail in a cage, from a mosaic from Beja, Tunisia, 5th–6th century AD.

Sunbird (*al-tummar*)[3]

Dust-coloured, about the size of a hen's chick. It hangs by its feet in the trees. Its call sounds like *Ana 'amut* (I am dying).

Al-batra[4]

A bird that seems to run under your feet before falling into the grass. Short-tailed.

Al-ghubrur

A small dust-coloured bird.

1 Kushajim 275: spells it *zughaim*.
2 Varisco 144: this bird is referred to as *salwa* (*Coturnix coturnix*) or *simman*. Al-Damiri 2/36: a white bird like the *sumani*.
3 Kushajim 173: spells it *al-tummayr* Houlihan 174: *tumayr* is the generic name of sunbirds (*Nectarinidae*) but the description does not fit. Dr S A Mohammed suggests a kind of small warbler.
4 Kushajim 173: spells it *al-tabra'*. Dr S A Mohammed suggests it might be some kind of lark.

Al-bahdala
A green bird.

Barred Warbler (al-dukhkhal)[1]
A dark green bird with two white feathers in its tail.

Al-abraq[2]
The plural is al-burq. It is a bird that eats millet.

Mushtari al-Hasan bi-ahlihi[3]
A bird with a yellow underside and a green back.

Common bulbul (al-nughar)[4]
The smallest of the sparrows which people in town call al-bulbul (nightingale). There is a saying of the Prophet, on whom be peace: this is what the little bulbul did.[5]

Corn bunting (al-hurraq)
It is a kind of sparrow which is called al-farq and in the plural al-furuq. It is of the al-sa'r kind.[6]

Hoopoe (al-hudhud)[7]

1 Houlihan 168: *Sylvia nisoria.*
2 Dr S.A. Mohammed: possibly a siskin (*Carduelis spinus*).
3 Kushajim 173: makes two birds of this: *mushtari al-Hasan* and *bahila.* Dr S.A. Mohammed suggests a greenfinch (*Carduelis chloris*) might fit the description.
4 *Pycnonotus barbatus.*
5 Kushajim gives a fuller version: The Prophet said to the boy of one of his Companions who had a bulbul that died: Abu 'Umayr, what did the little bulbul do?
6 Viré, 1967, 274: *hurraq* is either the corn bunting (*Emberiza calandra*) or the ortolan bunting (*Emberiza hortulana*) but the former occurs more frequently in the Arab world. Kushajim 274: spells all these names differently: *al-khurraq, al-gharq, al-ghirdaq* and *al-sa'u* (see note above on *al-dujra*).
7 Houlihan 162: *Upopa epops epops.* Wensinck, *E.I.* 541-2: legend has it that King Solomon made it king of the birds: hence the crown on its head. The Prophet is said to have forbidden it to be killed; hence according to some its flesh is forbidden but others regard it as permissible. In N. Africa hoopoes are made out of silk, feathers, etc. and used for magical purposes.

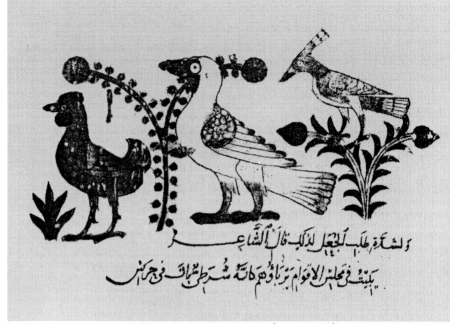

40. A cock, vulture and a hoopoe from a late 13ᵗʰ / early 14ᵗʰ century manuscript illustrating the zoology of al-Jahiz

It is also called *al-hudahid*. It does not have a nest but a hole in the ground.

Al-kahla

A bird of the *al-dukhkhal* (barred warbler)kind.

Al-sulaa

A dust-coloured bird with marks like tattoos and long legs.

Allen's Gallinule (*al-furfur*)

A bird.[1] The plural is *al-farafir*.

Common quail (*al-summana*)[2]

A dust-coloured bird with a long tail, black eyes and a yellow beak.

1 Houlihan 153: *Porphyrio alleni*, a water bird like a moorhen.
2 Varisco 144: one of the names of *Coturnix coturnix*.

Crested lark (*al-qunbara*)[1]

One of the sparrows, it is dust-coloured and about the size of *al-niqar*. It has a tuft of feathers on its head. It is also called *qubbara*.

Common bulbul (*al-ku'ait*)

The bulbul; and the plural is *ki'tan*, and its call is *al-'andala*.

Al-qawari

The singular is *qariyya*.[2]

Al-qawba'

A red bird with long legs, it is as if its grey head has been painted.[3]

Al-mudabbaj[4]

Ibn tamra

It is the smallest of birds. It protects the dates as well as the bees and hornets.

Woodpecker (*al-qawwa'*)[5]

It is like the *qariyya*. It has a curved beak and yellow legs.

Al-qum'ul

A black bird with a short neck, beak and legs. It is dusty yellow on the top of the head.

1 Houlihan 164: *Galerida cristata* is common over the whole region. Thekla's lark (*Galerida theklae*) is very like it in appearance with a similar crest.
2 Al-Damiri 2/335: it is a short-legged, long-beaked bird with a green back. Possibly the green woodpecker (*Picus viridis*). Al-Baladi 194 n. 3: suggests a bee-eater, possibly the little green bee-eater (*Merops orientalis*), which occurs in Arabia.
3 Kushajim 274: spells it *al-hawba'*. Al-Damiri 2/376: it is a black bird with a white tail which it moves a lot.
4 *Lisan al-Arab* says it is an ugly water bird and Kushajim says it resembles the *qamri* but is larger..
5 Kushajim 274: spells it *al-qurra'*, which Ilava says is a woodpecker.

Parrot (al-babagha)[1]

An intelligent bird. The Persians used to take it into the palaces of their women. It repeats everything that happens.

Miscellaneous

All those that have curved claws; unequal halves of the beak: strong thighs; deeper and broader breasts than those of other birds; well-separated feet, except for those which swim, because the toes of the feet are webbed; while other birds that fly high above them in the sky have four toes on each foot, three forward and one back, they have an extra toe because they need it more for walking; they have no marrow in their bones; to escape the cold of the water, their feathers are oily in order not to become wet.

The eggs of birds found in thickets and pasture indicate the layer because of their colour and there is a difference between them and desert birds. If they are white it indicates they are of the partridge or pigeon, and the oblong eggs produce hen chicks and the circular ones which are broad at the ends produce cock chicks.

He said: Thus we have mentioned all the well-known birds that exist.

Bats (al-khuffash)[2]

This is al-watwat and al-sahaa. There is no joy in hunting it except for its meat and the fat on it for feeding the birds of prey.[3] It menstruates and gives birth to its young. It flies without feathers and does not appear in the daytime. It eats gnats. It carries its young and flies with them, sometimes suckling them as it does so. Its sight improves throughout its life. Those that appear by moonlight are the old ones.

Locusts (al-jarad)

If the female has eggs she turns black. They call the eggs: al-sar. They are laid in the ground, in a rough place in which not even the axe can break: she pieces it with her tail and deposits her eggs. They stay in the ground for forty days. Then they rise up as small white locusts, next they start eating and finally they turn black and cover the ground. After 15 days they shed their skin and are kitfan. If wings appear the locust is called al-ghawgha, but if it turns yellow it is al-khanfan.

In the sayings of the Prophet: it is like a fish's gills.

1 There are no indigenous parrots in the region. There are two parakeets: the ring-necked (Psittacula krameri) and the Alexandrine (P. enpatria), both of which would be called babagha' in Arabic but neither is known for its mimicry. It seems probable therefore that this is a matter of an imported species.
2 This is the generic name for bats in the region of which many species are found.
3 Graves 323: in the early 1920s Sir Percy Cox used to catch them in big butterfly nets when they flew over the garden wall at the British Residence in Baghdad to feed to his eagle and falcons.

They call a swarm of locusts *rijl, hizqah* and *takhfa*, the male *'unzhub* and the female *'aisa*. They are caught in any way that presents itself.

It is one of the animals without blood, like all fliers without feathers, but it has notches.

They say that it builds a bridge over a river one on the other over which the remainder cross. When breeding the female puts an organ into the male.

It is one of the harmful foods and increases *al-kimus*[1] and inflammation.

1 *Al-kimus* is derived from the Greek *melas khymos* meaning black bile.

Chapter On Fishing

As for prey from water, they say in brief that the best is caught from cold rivers which often rise and fall and steeply descending rivers that are not hidden by trees or overhung by mountains.

The more the water is clear the better the fish. So the fish of the Tigris are better than those of the Euphrates and the fish of the Euphrates are better than those of the Nile. Loathed are the fish from wide-bedded rivers, the thickets and still waters, for the putrid things they produce in their stillness are loathsome and increase the fluids in whoever eats them. Rivers with a deeper bottom are best.

It is best to catch fish by sluices and dams; and netting by night is most successful in view of what they claim about fish sleeping. The catch on moonlit nights is greater because the ebb begins with the movement of the moon from the eastern limit to the middle of the sky.

Some catch fish with nets and spears in clear water, with dams, grabbing them with the hands and with hooks.

They relate that a bird swooped down on a large fish in Basra with the intention of swallowing it. It stuck in its beak and some people found it in this condition and they all ate of the fish.

The book is finished with praise to Allah and his support.

May Allah pray for our lord Muhammad and his family and keep them well.

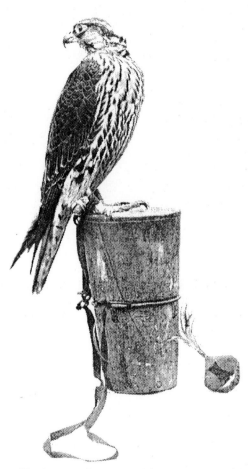

41. A young Peregrine falcon on its stand.

From al-Kafi *On Hunting*[1]

A Saluqi may also be trained with the two peregrines:[2] it assists them in hunting, just as the hound assists the saker falcon[3] in hunting gazelle. The basis for this is that the hound should accustom the peregrines to it from the first time they are carried, while they are still wild, so that neither of them should become afraid of the other. The hound should be present when they are called to the fist and when they are fed, so that they get on familiar terms with each other and like to be together and so that the hound becomes accustomed to them and keeps his eye on them when they are circling overhead.

If they are circling and cranes or geese are made to fly towards them; and if they stoop on one and strike it in the sky; and if they should take turns at it and it should fall to the ground or come close to it; the hound would take it from under them. This is the easiest way for the peregrine to hunt the crane, because if the crane sinks to the ground it is difficult for all raptors to take it, since its habit is to kick or strike with its beak; whereas it is easier if it is flying in the air.

As for the saker, if it comes as an eyass, its training is like training the goshawk[4] eyass until it grows strong and ready to fly, when it has to be taught and trained for hunting. The saker eyass is of little use and advantage, unless it is exceptionally one of those eyasses from the best sakers, because it needs teaching and training for hunting to the point of weariness, but it will be very tame and far from flying away.

Training the young saker eyass after it has become accustomed to responding to meat, to the lure and to wearing the hood, is as is done with the peregrine. If you want to train it to hunt gazelle, accustom it to the hound, as is done with the peregrine. Then take a gazelle fawn, slaughter it and skin it completely with its head, ears and tail. Stuff the skin with straw, making it into a dummy as if it were a real live gazelle. Fix onto its head a piece of red meat bound round with strong string.

1 The author is 'Abd al-Rahman b. Muhammad al-Baladi who probably lived in Baghdad around the end of the seventh century and the beginning of the eighth century AH (13th/14th century AD). This extract is taken from the edition by Ihsan 'Abbas and 'Abdulhafedh Mansour, who authorised the translation.

2 Arabic - *shahin* (*Falco peregrinus*).

3 Arabic - *saqr* (*Falco cherruq*).

4 Arabic - *baz* (*Accipter gentilis*).

Show it to the saker. If it asks for it, release it so that it lands on the head of the gazelle. Let it peck three morsels from the meat. Cover the meat so that it cannot see it and does not know where it has gone, move it so that it thinks it is between its feet in the fur of the gazelle and it will pluck at the fur. If it plucks at the fur one or two pecks, cut a piece of meat for it and put it in the fur between its feet in the place where it was pecking. Do not let it see that you are putting it there for it, so that it thinks that it has appeared from the fur. If it eats it, put some more, without it seeing you, until it is full. Then take it from the gazelle's head and do not show it to it. Repeat this the next day for three days. Do not be generous with its food but moderate. If you see that it demands the head of the dummy if it is sees it, feed it on top of a live female gazelle fawn without horns.

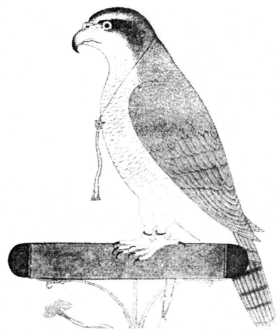

42. An intermewed goshawk from a Persian painting.

The way of feeding it is to give the fawn to a man to take into his lap, holding its legs so that it cannot move. Then fly the falcon at it and if it wants it, lands on its head and pecks at its fur, which is the object, let it peck. Then scratch the gazelle's ear with the point of a knife so that the blood flows. Cut some pieces of meat and throw them one at a time on the gazelle's head, so that it eats them without seeing that you are cutting the meat and feeding it until it is full.

If it does not want the gazelle and does not take it, tie the meat to the gazelle's head. If it descends on it, let it feed until it is full and peck at the fur. Repeat this the next day for three days. Then fly it at the gazelle without meat after you have starved it. If it wants it and takes the head, let it eat its fill on it and continue for three days. Then tie up the gazelle's forelegs to its chest. Put it on the ground alone without anyone holding it and fly the saker at it. If it takes the head, let it eat its fill on it, while continuing to keep it away from the gazelle. Repeat for three days. If the saker, when it sees the gazelle, starts to want it and to leap on it, free its jessels and manacle its legs with strong string. Tie it on one leg and tie the other end on the other leg. Do not make the string long between the legs: the length should be no more than an arm's length. Tie in the middle a long rope (creance[5]) the end of which is held by a man in hiding. Then you manacle its feet in the same way too. Let it go from there so that the saker does not see you. Then take off the saker's hood. If it sees the gazelle and wants it, fly it at it. If it takes its head, order the person holding the rope to yank it so that it is pulled down and is prevented from kicking the saker. Then feed it full on it. Do not forget the call, but call it every day before feeding it on the gazelle from a faraway place. Let it taste the meat but do not let it eat its fill anywhere but on the gazelle's head. Continue feeding it on the gazelle, which is tied up, as we have mentioned, for three days. Then if you see that it is keen to demand, tie two of the gazelle's legs with a long rope and do not manacle its feet. Let it go and order the person holding the long rope, who is hiding in the grass or behind a rock or tree or something like that, to make the gazelle walk about held by the rope, one end of which is in the hand of the hidden person. Then lift the hood of the falcon, if it wants let it fly and if it takes the gazelle's head, the gazelle will struggle under it. Let it work at it for a while but not for too long the first time. Then take it off . Order the person holding the rope to pull it in so that the gazelle falls under the falcon. Feed it, as we have mentioned. Repeat for three days. On the fourth day tie the muscle of one of the gazelle's legs above its knee and below the thigh tight with strong string and wrap the string round it so that it is no longer able to run, then let it go without a rope. Lift the hood of the saker and fly it at it. Let it work on it and then get it to feed on. Let it rest for one, two or three days, do not go out with it, but feed it on call with a light meal to keep up its strength. Then seek Allah's guidance and go out hunting with it. If you observe some wild gazelles, look whether there is a female among them. Lift off the saker's hood and fly it after saying the Basmallah. After flying it slip the Saluqi, which you have accustomed to the falcon, because it will be held by you on a slip lead, as is usual with hunting hounds. Then see what it does. Set off on your horse shortly after slipping the hound and flying the falcon and do not stop. Keep the horse running until it exceeds its speed. If your horse is good, it is better than the slow runner. If the falcon is a jewel, you will not return home

5 The creance is tied and held by the falconer to keep the falcon under control so that it does not injure itself.

without hunting with it. If it is listless and does not hunt that day, do not feed it the next day at all and go out with it in the evening. If it hunts, good, if not, do not feed it at all and leave it till the next day. Then take it out the next day and the third day, completing a whole week. If it does not hunt anything, leave it alone for three days. Reduce its food on call, then take it out hunting on the fourth day. If it hunts, let it eat its fill from the prey, after it has been killed. If it does not hunt and does not want to or does not come to strike at the gazelle's head, or when you fly it it turns and flies high but does not advance to the gazelle without reproach, then recognise that it will not succeed and will be no good. Transfer it to something it finds easier.

As for teaching the falcon to hunt hare, it is like teaching it to hunt gazelle. Every falcon trained to hunt gazelle can hunt hare like gazelle. Some falcons will hunt hare naturally without being taught.

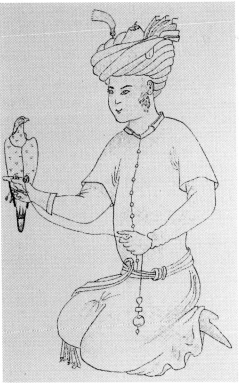

43. A Persian prince and his falcon.

Index